The Art of Portrait Photography

CREATIVE LIGHTING TECHNIQUES AND STRATEGIES

BY

MICHAEL GRECCO

ART DIRECTION AND DESIGN BY CHARLES HESS

AMHERST MEDIA, INC. • BUFFALO, NY

For more information on Michael Grecco and his work, please visit his web site at <www.greccophoto.com>. He may also be reached via his publisher at the address and fax number listed below.

Copyright © 2000 by Michael Grecco.

All rights reserved

Published by:
Amherst Media, Inc.
P.O. Box 586
Amherst, NY 14226
Fax: (716) 874-4508

Publisher: Craig Alesse
Project Manager: Michelle Perkins
Design / Art Direction: Charles Hess of c.hess design
All photographs by the author.

ISBN: 0-936262-85-0
Library of Congress Card Catalog Number: 98-74042

Notice of disclaimer: The information and suggestions provided in this book are based on the experiences and opinions of the author. The author and publisher will not be responsible or liable for the use or misuse of the information in this book.

Printed in the United States of America
10 9 8 7 6 5 4 3 2 1

This book is dedicated to my wife Toby, because her love and support gave me the time to write it and to the memory of Chris Farley for one of my more memorable shoots. I would also like to thank my staff, Jason Hill and Edward Duarte, for their support and contributions to my work. Also to my children, Dakota and Sophia, who gave me my playtime between bouts of writing.

Introduction

Light is the reason we see, and when light strikes film or digital camera backs, it is also the energy that creates photographs. The word "photography" means writing with light. I don't say this to be trite, but looking at photography this way forces you to make a conscious choice about what that light is going to look like every time you set up a shot. Whether you are a portrait photographer, a still life photographer, a landscape photographer, or a photojournalist, light is the means by which you communicate whatever it is you need to say.

As a portrait photographer, every shot I take requires me to determine not only what the concept or feeling will be, but also how best to accomplish its expression. This means that once I have the idea, I must still plan the sets, the wardrobe, the make-up and, of course, the lighting. The way I use these elements to make a general statement about my subject is strongly influenced by my personal artistic perspective. As photographers, we are like artists of every media who work with identical materials (be it paint, clay or stone), but form them in uniquely personal ways. Just as a painter uses his particular brush strokes to express an original message, the artistic style of the photographer (for me expressed in part by the light) becomes an integral element of the work.

I consider myself a "conceptual" portrait photographer. That means I like to tell my story of who I think my subject is, but not in a literal way (not using signs or specifics). I like to be abstract about the story I tell, and to convey the concept on an emotional level, with light and shadow. I think the absence of light is just as important as the addition of light. Many photographers just try to bring the light level up high enough to be able to shoot at a comfortable shutter speed and/or f-stop. To me that approach robs you of the opportunity to explore all of the possibilities available to you.

Because light shapes my images, I depend on my equipment a great deal. Yet, it's only equipment; I don't worship it, I use it. I think too many photographers get hung-up on the equipment itself, and forget that the important thing is to use the equipment to solve a problem, namely making a great picture. You must never lose sight of that, regardless of what equipment you use. The following suggestions represent the equipment I have found works for me.

I travel a lot and rent studios when and where I need them. Because I don't have a studio of my own, I love Dyna-Lite strobes for their size and portability. I use the 1000 watt/second packs, which are both small and fairly powerful. I own four packs and seven heads. I have also found them to be very efficiently designed because they use the same attachment as my Lowel hot (tungsten) lights. Since I frequently mix hot light with strobe light, this is quite beneficial.

There are also times when I am outside with no power. If I don't want to have to rent a cumbersome generator, Comet makes a relatively small and very powerful battery operated strobe, the Comet PMT 1200. The battery pack can also be plugged into the Dyna-Lite heads with a connection cable made by Comet. This allows me to use the very efficient Comet heads, or any Dyna-Lite head, and any Dyna-Lite attachments.

I also use a custom-made Fresnel strobe head. It's an old Mole-Richardson Studio 2K that had the guts ripped out and a Dyna-Lite compatible strobe head put in. I can even power this with the battery operated Comet PMT pack. The conversion was done for me by Flash Clinic in New York. Another specialty piece that Flash Clinic made for me is a modeling light delay switch. It's a little box, with an optical slave in it, that plugs in between the strobe pack and the head. When the flash goes off it turns off the modeling light for a variable amount of time. This is useful when mixing light sources during long exposures, because it eliminates the blur and ghosting that could be caused by subject movement with the modeling light on.

To form shadows, I carry a flag case around with me the has the normal "cookies," pattern boards and scrims in it. I'm also a "pack rat" and save pieces of foam core and things I have used in the past to cast shadows on the walls. I have collected many useful shadowing devices

In this book, I'll show you my best images, but I'll also tell you how I made them, the concepts behind them, and how I lit them to get the desired effect. The lighting diagrams, the captions, and the stories behind the pictures, are as important as the final photographs.

from various shoots — sheets of metal with varying sizes of round holes, foam core with "dancing squiggles" in it, little stick figures on wire, etc.

With cameras, the format you work with can set the tone of the shoot by either making it monumental (shooting with a 8x10 camera) or more free spirited (with a hand-held 35mm auto focus). On most shoots I use medium format cameras, and bring both of my medium format systems with me. I use a Hasselblad system for its reliability and small hand-holdable size, and a Fuji GX 680 system for the 6x8cm format and for the lens tilts and shifts. On occasion I will try to "loosen up" the shoot and mix in some Canon 35mm shots. I might do the "set-up" shot or concept shot, and then shoot available light, hand-held with the Canons, or shoot "behind the scenes." On occasion, the shoot also calls for a 4x5 format which we will also use. Basically, you need to push yourself to experiment and see what feels right. **Whatever format you choose, be sure to give yourself the time you need to get "in-sync" with your equipment.**

For film I usually stick with the same basic stuff, shoot after shoot. I love shooting slide film and almost always use Kodak E100S. I love the saturation and the skin tones. For black and white film I use Kodak Tri-X, which has a wonderful grain and feel. Sometimes I will also shoot some Kodak EPY tungsten for a blue look, or EPN if I am going to cross-process it (i.e. run the E-6 or slide film in a C-41 or negative chemistry, resulting in a image with unique saturation or punched-up color). **Ultimately, the best way to select a film (or films) is to test and experiment on your own. Each photographer's lights, cameras, and personal style lends itself best to the use of different film.**

Some photographers approach the whole idea of style differently from the way I do. They achieve a lot of their "look" from experimenting with different kinds of film and altering the processing. You can use high-speed film for the grain and push it to further enhance that look. Some of the negative films are very flat looking and give more of a pastel palette. There are even slide films now that are made to be pushed, but when you don't push them, they give a more pastel palette also. I have enough tools to work with every day that this is not my specialty. This is one area where you really need to see what works for you! **Experiment as much as you can.**

SUBJECT:	Kid in Tub
CLIENT:	Holiday Inn
LOCATION:	New York, NY
NOTES:	Primal Light Studios

Lighting Demonstration

This is a lighting set-up for an ad for Holiday Inn. It was a funny concept with a kid in the tub who had made animals and objects out of shaving cream.

To accomplish it, I hired both a model maker and a food stylist. The model maker built a Styrofoam base for each object and the food stylist and assistant sculpted shaving cream over them to make them look real.

I originally wanted to add a window light look on this set, but the client felt it was not true to their hotel bathroom designs. So instead of getting discouraged, I got creative and "messed it up" — breaking up the window light effect. I ran tape across the foam core board which was making the window shadow. I added opal (a very thin diffusion material) to some of the "panes." We added tree leaves in the form of gobos (shadow boards made to alter light). **By the time we were done it was not window light, but a nice touch that still brought out the kid in the tub.** The rest of the set was lit with a big fill light in the front (a silk with a head behind it), and a medium soft box directly over the tub. These other lights helped balance the overall mood of the room.

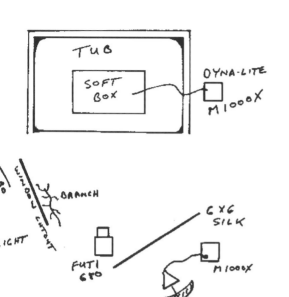

TUB

SOFT BOX

OYNA-LITE

M1000X

GOBO

FLAG

WINDOW LIGHT

BRANCH

HOT LIGHT

FUT1 680

6 X 6 SILK

M1000X

UMBRELLA

This is a typical set for us, not as glamorous as you might think, but very functional. The main light is a soft box way above the tub. The shot is filled in by a silk to camera right, and a touch of "window" light from camera left.

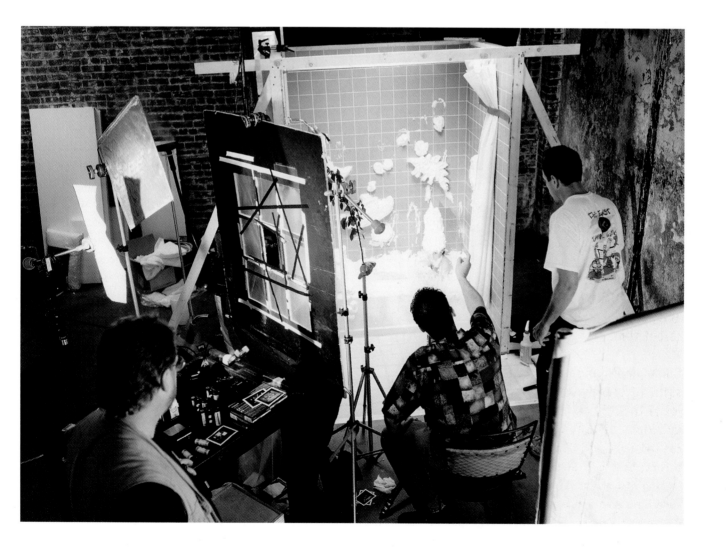

SUBJECT:	Christian McBride
CLIENT:	Verve Records
LOCATION:	Zoom Studios, New York
NOTES:	Solarized Polaroid & Tri-X

Music Packaging

This is a solarized Polaroid 665 black and white negative shot in the Fuji 680 camera. The background was a white wall lit one stop brighter than the camera's f-stop. His eye and face were lit with a 3° grid spot.

This is one of my favorite series of photographs. They were taken for Christian McBride's CD packaging. He is an incredible bass player whom I have admired for a long time. **It's great for me to work doing what I love**, it's especially great when I really admire the person I get to spend the day with.

I started out shooting him on white paper and trying out some ideas I had for shooting his profile. The art director then asked me to shoot the subject straight on. Since I always enjoy the collaboration part of the process, I was happy to do it. I also had in mind to try a special technique. I had been experimenting with solarizing the Polaroid 665 positive/negative film. The Polaroid positive/negative film looks like regular Polaroid, but the dark half that you normally throw away, when washed properly, is a negative. Solarization is a technique normally done in the darkroom. As a print is developing you turn on a room light or expose it to light and parts of the print reverse to negative. Sometimes only the edges of objects will turn to negative or change tonality. **With Polaroid 665 (or 55), solarization can be done while it is developing by pulling it apart early and exposing it to a bright light.** Usually only the shadow areas of the Polaroid solarize, so I knew that if I only lit his eye, all of the other shadow area in the shot would solarize. When I pulled the Polaroid apart and started solarizing it under the hot light I was blown away by the result.

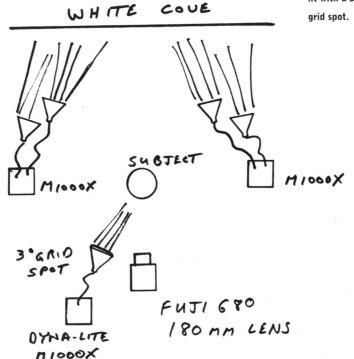

WHITE COVE

M1000X

SUBJECT

M1000X

3° GRID SPOT

FUJI 680
180 MM LENS

DYNA-LITE
M1000X

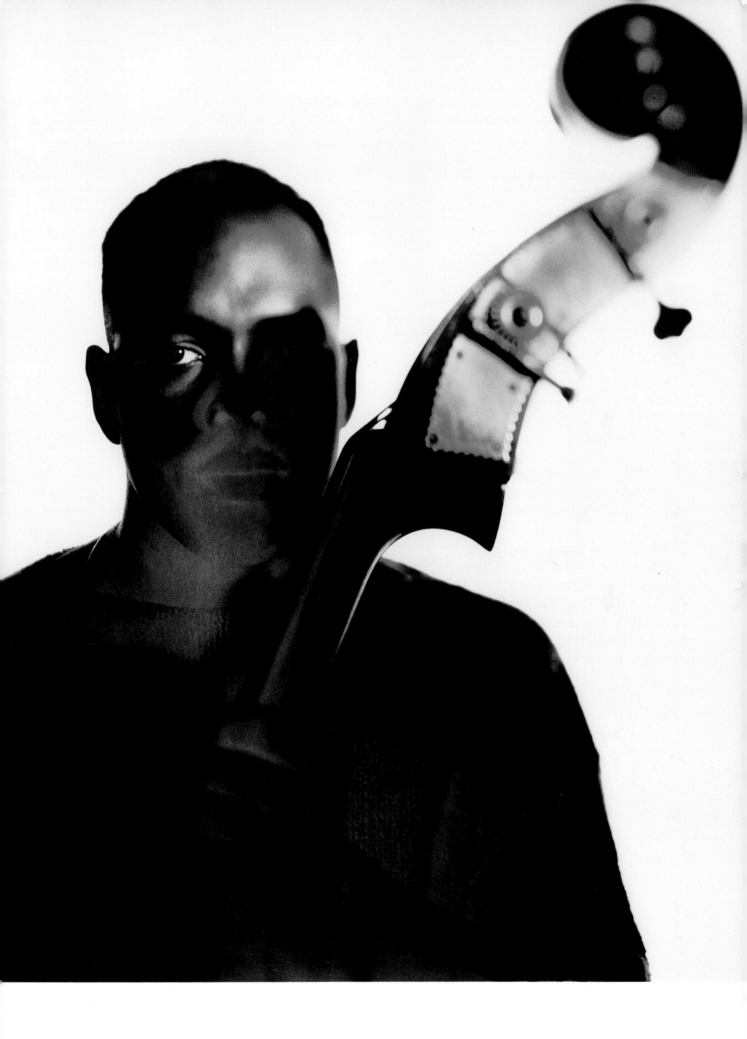

The best part about doing a CD package for me is the inset shots or coverage of non-cover subjects (right). In a way, it's just like shooting a photo-journalistic story. **The bass head shot was just a journalistic picture.** As a student, I wrote a paper on a then obscure art photographer Frederick Sommer, whose image of an out of focus violin I have always loved. I thought of that image when I had to do this close-up of the bass fiddle head. I shot it both solarized and un-solarized but the solarization added incredible tones and dimensions to the out of focus scrolling lines of the instrument.

Another inset shot was Christian playing (opposite page). When you shoot a CD package like this you often have to shoot many different things, and do it very quickly. Here, I was shooting him in front of white paper with strobe lighting and wanted to capture the ferocity of his playing. So instead of changing anything in the scene, I just unplugged the strob sync from the camera and shot him playing using only the modeling lights from the Dyna-Lite heads. This gave me an exposure of approximately one second. **This long exposure is what creates the blur and captures that sense of movement and energy I wanted to depict.**

For this shot the art director held the bass up near a wall with a ceiling light on it. This is also a solarized Polaroid 665 black and white negative shot with the Hasselblad using a 120mm lens.

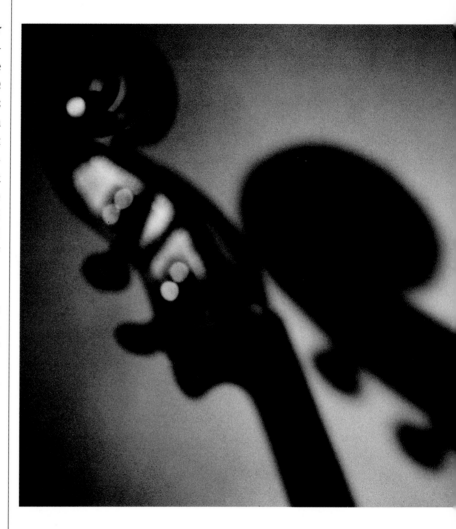

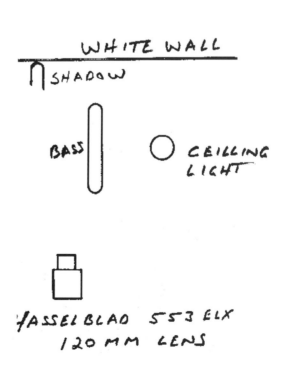

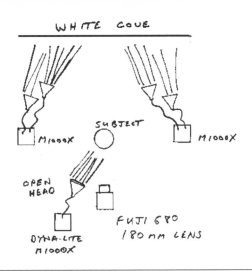

WHITE COVE

M1000X SUBJECT M1000X

OPEN HEAD

DYNA-LITE M1000X

FUJI 680 180 mm LENS

The strobes in the rear were at full power to make the background white for the previous shot. I turned them all the way down to make the background gray and turned the modeling lights off. I then pulled the slave out of the front light and pulled the grid off of it. This picture was made at a full second using the modeling light from the front strobe and the flash from the rear.

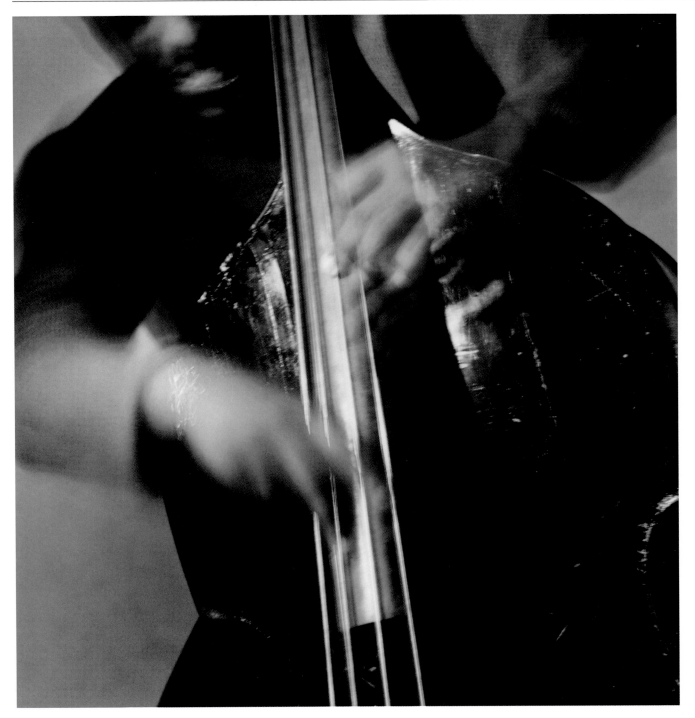

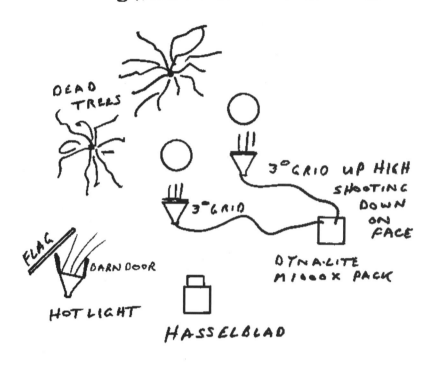

SHADOWS ON WHITE COVE

DEAD TREES

3° GRID UP HIGH SHOOTING DOWN ON FACE

3° GRID

DYNA-LITE M1000X PACK

FLAG

BARN DOOR

HOT LIGHT

HASSELBLAD

Inspired by Dreams

This is another favorite picture of mine. As you can probably tell I like music, so I was happy when Rolling Stone called and asked me to shoot the band Dead Can Dance, whose music I knew and loved. My immediate words to the photo editor were, "dead trees." **Sometimes I dream my ideas, sometimes they get worked out with the creatives I am working for, and sometimes things simply derive from the subjects I shoot. This idea just came to me immediately.**

Anticipating that I would use the shadows of the trees as well as the trees themselves in the photograph, I wanted a background that was simple. I chose a white wall for the background and shot in a near-by studio in Pasadena, CA.

I placed one tree in the background and another to the left side of camera with the subjects in the middle of the shot. The lighting for this shot was in some ways both simple and complex. I originally tried to light the background with multiple lights but found that the shadows they created were too intense, and too complicated. Instead, I used one hot light to the left side of the camera. Using a hot light allowed me to precisely set the light where I needed it. The light first lit the front of the branch on the left and then created the shadows of the other trees on the backdrop. I lit the band with two 3° grids on Dyna-Lite strobe heads directly overhead. **I like breaking "rules," so I felt free to set the lights too high and not to catch the artist's eyes. This is what gives his eyes that sense of darkness.** Her eyes were lit the same way, but when she looked up it gave the shot a mix of beauty and mystery.

A hot light illuminates the entire background of this shot. The band members are lit with very high 3° grids pointing down on just their faces. It was shot against a white cove wall.

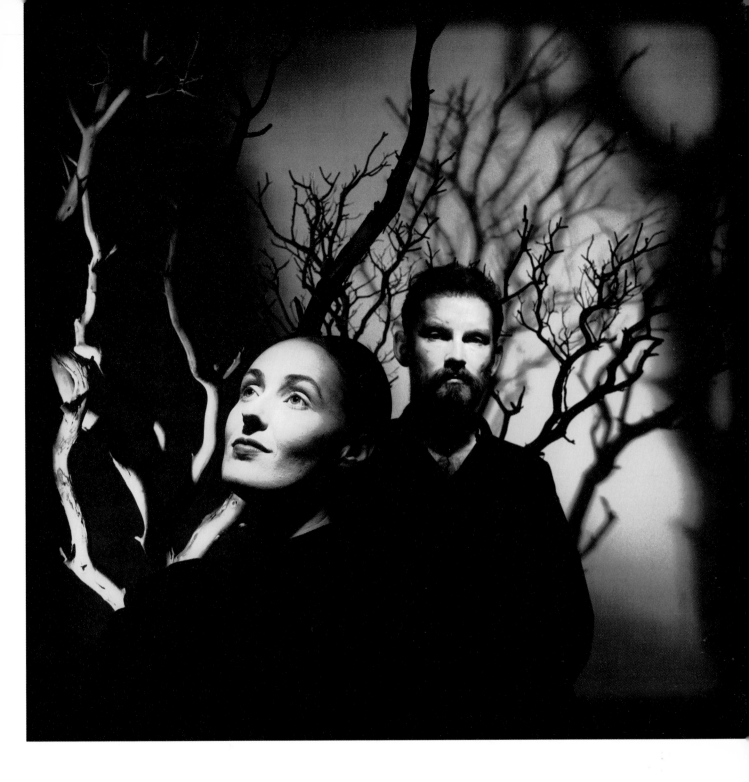

BJECT:	Dead Can Dance
LIENT:	Rolling Stone
ATION:	Los Angeles, CA
NOTES:	White Cove

SUBJECT:	Al Jourgensen
CLIENT:	Ray Gun
LOCATION:	Austin, TX
NOTES:	Various Multiple & Time Exposures

Finding Inspiration

This was a cover story for Ray Gun Magazine. My assistant, the writer and I were sent to do **a story on Al Jourgensen of the band Ministry.** The shoot was to take place on Thanksgiving Day – what a time to travel! We had to take the red-eye through Las Vegas to get to Austin, Texas for a noon shoot that didn't actually end up happening until 8:00pm.

The magazine article was about his many projects and his different bands. Since I knew his music I had the basis for a few ideas about shooting him (if I hadn't known his work, I would have researched it before the shoot, as I do with other musicians). My idea was to do some bizarre pictures with large pieces of metal to play off what I thought of as the artist's industrial sound. I had a prop stylist get large bolts, nuts, wire, and general pieces of hardware. The general inspiration came from a favorite picture of mine, by Michele Clement, of a head made into a machine filled with hardware. As I will discuss again and again in the book **I love to come prepared with lots of ideas and then keep my eyes open at the shoot and be prepared to adapt. That means being prepared even to throw my preconceived ideas out the window if necessary.** As you'll notice, I often draw some of my concepts from other visual artist's whose work I like. From this starting point, I can then adapt the concept to suit my own style and the particular subject

This image (left) is one where I had to throw out every idea I had come with and start fresh. Al hated being associated with the genre of industrial or metal music, because he doesn't see his music this way. On my way out of my house for this trip, I had grabbed some little gargoyles from my house walls. I then realized that the faces could be used to make a visual connection with his multiple bands and multifaceted persona as a musician. So I did the next logical thing, and asked him to stick one in his mouth. Why not?

I strobed the right side of his face and lit the left with only the modeling light at a full second exposure. Both heads (on either side) had 10° grid spots on them.

Since now variations on the metal theme were out of the question, another great photograph came to mind. The shot was Gregory Heisler's Time cover of David Lynch, were he had one eye pointing one way and one eye pointing another. **As you can tell I look at every magazine I can possibly get my hands on for what's going on and what inspires me.** As luck would have it, Al preferred not to take off his dark glasses. In looking around his house I again came back to this multiple persona theme and used his cow skulls as a background.

I had one strobe connected to the camera with a 3° grid spot, and another head on a separate pack next to me that would not go off until I pushed the fire button on the pack. When the camera went off, the connected strobe lit one half of his face. With the shutter still open I had him turn his head. I then popped the other strobe next to me that was on the other side of him and made the second exposure of his face.

In the picture on the opposite page I wanted to capture what I thought of as the chaos and hard edge in the music that Ministry does. I also loved this sixties-style chair. I sat Al in the chair with his guitar, then used one under-powered 10° grid spot and mixed it with the ambient room light. I then shook the camera a lot during the exposure. In some shots the strobe was brighter and on his face, in others I had it dimmed and pointed downward. By varying the power of the room light and the power of the strobe, I achieved variations in the sharpness and blurriness. The whole story turned out to be a great piece and was used by the magazine as a six page spread.

I used 10° grid spots on either side of the subject's face on separate strobe packs. The one on the right was attached to the camera and went off when I fired the camera. The other pack I fired manually at the end of the exposure, after he turned his head.

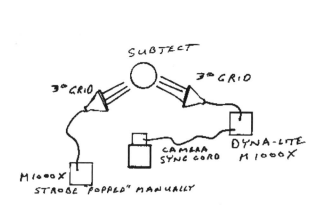

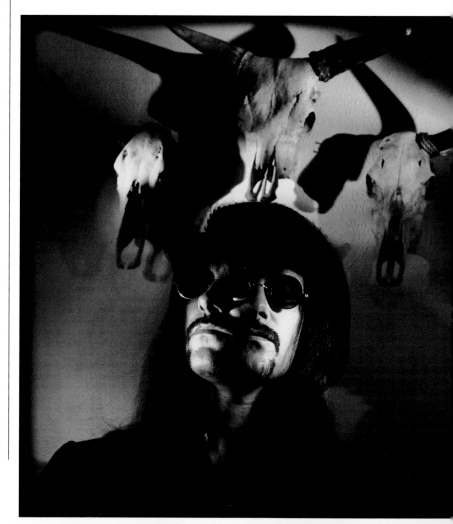

A Lowel Omni hot light lit the room during a time exposure. I also strobed his face so that something was sharp in the image.

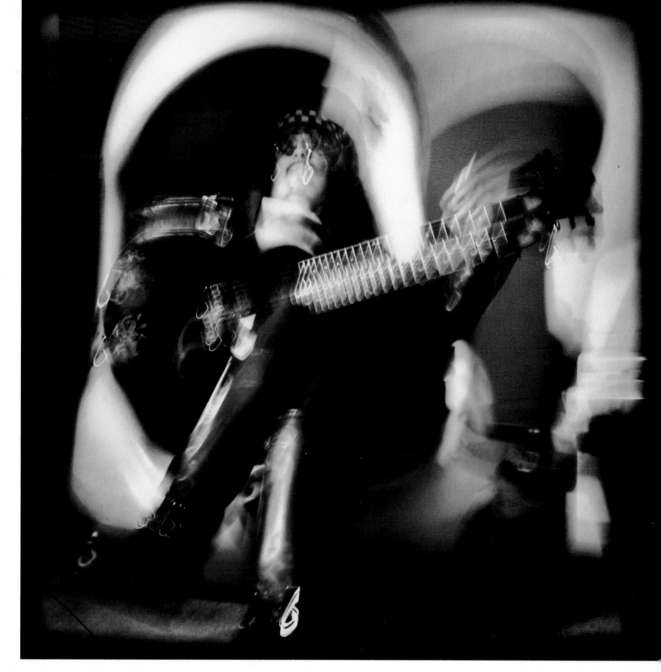

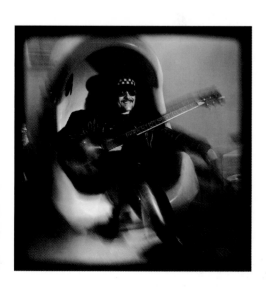

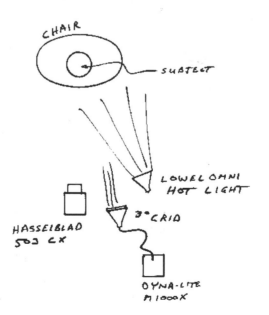

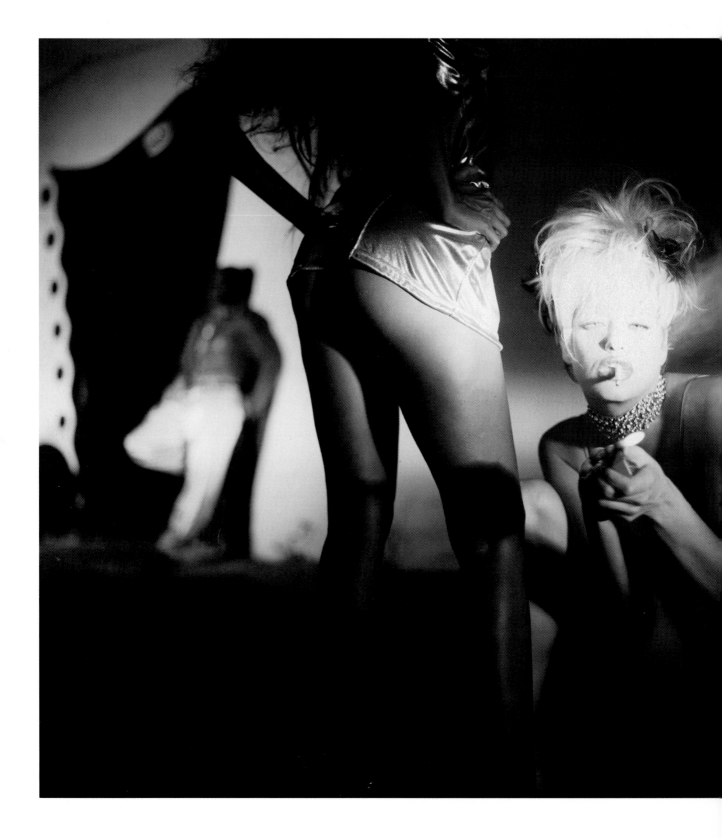

I was scheduled to go to Miami to shoot an annual report and decided to fax some of my clients to see if any of them had other assignments I could do while I was there. In response, Ray Gun Magazine asked me to do a fashion spread, and I proposed a club fashion piece. On an assignment like this, I am usually given pretty much free reign to conceive and execute my vision, so I put together a wild cast and crew of models, stylist, hair and makeup. Recruiting people for the shoot was a bit tricky, since it was early summer at the time and quite a lot of people escape the heat by going up to New York at that time of year.

Since I am working almost constantly, **I have the opportunity to do much of my photographic experimentation while on assignment. This is a perfect example.** I shot with Kodak high speed 400/800/1600 slide film, and generally allowed myself to break more lighting rules than I usually do. The general idea for this story for me was to be funky, in whatever way I saw fit. That meant using interesting lighting in the first image, and the funky mirror and simple lighting in the second image.

The first image (opposite page) was shot in an alley. **I used a car's headlights to light the women,** and one battery operated Comet PMT to light the club kid in the background. It was 2 a.m. and the only additional illumination came from the street lamps. I posed the woman in front very close to the car light to let her face overexpose and "burn-up." The light on her was a least three stops hotter than the overall picture. I've always liked the Rene Magritte painting "Illuminated Man" where the subject's head is just a glow. The effect here is quite similar.

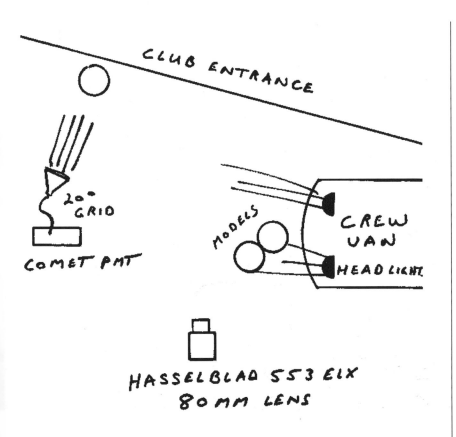

Cutting-Edge Fashion

CLUB ENTRANCE

20° GRID

COMET PMT

MODELS

CREW VAN

HEAD LIGHT

HASSELBLAD 553 ELX 80MM LENS

The models were posed in the middle of the alley in front of a Miami club entrance. They were lit with the head lights from our rental van.

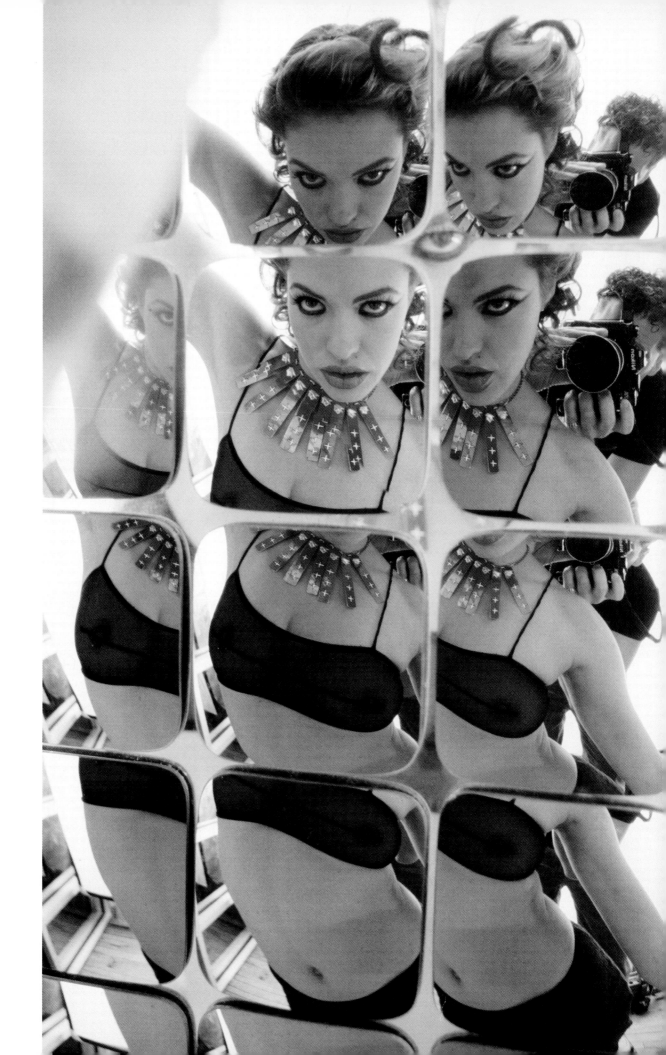

The second image (opposite page) was shot into a multi-paned mirror. My intention was to isolate the model and myself in the frame. This clean and simple composition allowed me to highlight, rather than detract from, this very cool mirror. Obviously, because of the mirror and wall it was hanging on, I could not front light the shot (front lighting would also have required me to shoot into the light). So the photograph was lit with one large silk placed directly behind me and the model. The silk was was placed close enough to almost fill the frame and to look like a white wall. The light (Comet PMT) was bounced into the white wall behind the silk so it would come through the silk very softly. The silk naturally went to white because it was both part of the shot and the light source. By the time the light hit the subject it was f/8, but if you took an incident reading of the silk it was f/11.5; this made it totally "blow out" or go to white.

To keep the background from being really distracting, I put a silk as close to my back as possible. I then lit the shot by flashing a strobe head in the wall behind the silk.

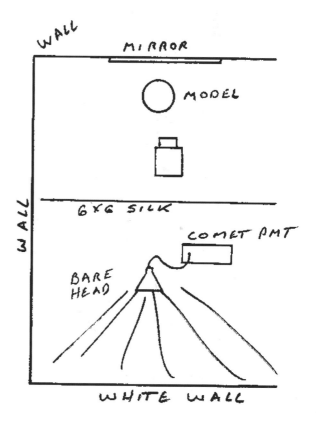

SUBJECT:	Salma Hayek
CLIENT:	Movieline
LOCATION:	Los Angeles, CA
NOTES:	Argyle Hotel Staircase

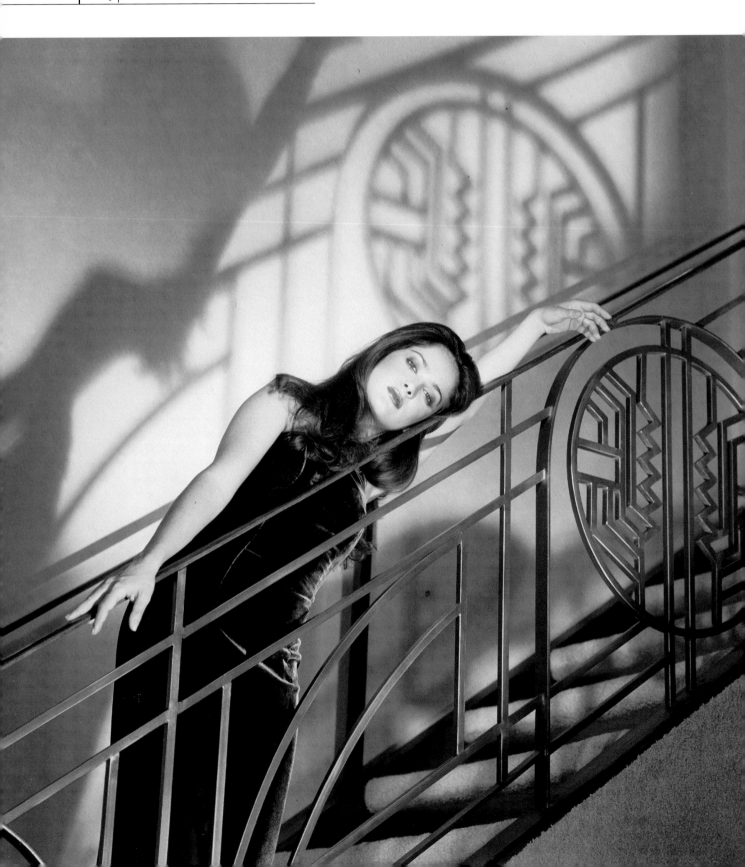

Painting with Shadows

I was assigned to photograph Salma Hayek for a feature in Movieline Magazine. We worked at finding an interesting location for the shoot and decided to do it at the Argyle Hotel in Los Angeles. The suites at the hotel have these amazing staircases that lead to the sleeping area on the second floor. **As soon as I saw the railing I knew it was too cool not to use.**

As my assistants and I were setting up the lights, they could not figure out why I was setting my Fresnel light so low to the ground and pointing at the rail. I had the image in my brain and through experience knew how to create it. **The room light was so bright though that you could not see the modeling lights, so no one else understood what I was doing until they saw the Polaroid.**

The railing was, to me, the most interesting part of this location, so I lit it to use its design as effectively as possible.

In addition to the Fresnel strobe light, I added a gridded Dyna Lite head to her face. This was pointed at the wall to make a secondary pattern of shadows. There was also a Dyna Lite head with a grid spot at the top of the stairs as a skim light to illuminate her dark brown velvet gown. Instead of setting up another light to fill in the shadow areas (so they were not black) I used the ambient room light. To do this I slowed the shutter speed down to 1/15 of a second, enough to bring the overall ambient light to about f/5.6. I shot at about f/8 or f/8.5 and used Polaroids to proof the shot the whole time.

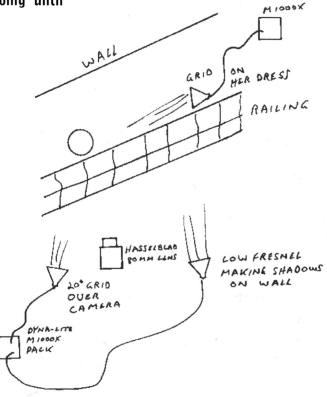

SUBJECT:	Wrapped Nude
CLIENT:	Self-Assignment
LOCATION:	Santa Fe, NM
NOTES:	Solarized Polaroid

I did this shot as a class demonstration at the Santa Fe Photographic Workshops by wrapping a model in clear plastic and photographing her with solarized Polaroid positive/negative film.

At the time I took this picture I had little experience shooting nudes. To change that, I often will shoot a nude for my class demonstrations at the Santa Fe Photographic Workshops. This is one of those demonstrations. My entire class was headed to an old welding shop that had great interiors, peeling paint, big wood frame windows – it was beautiful.

I lined up the model I used for the "Jill in the Box" shot (page 125) and, as always, wanted a hook – to do something unusual with her. I had the idea of wrapping her in clear plastic, playing with the concept of being nude. **Since I came up with that concept at lunch and there was a clear plastic tablecloth on the table, we commandeered it** (after asking nicely of course).

I shot this image with my Hasselblad, using the Polaroid negative/positive film and solarizing it. The trouble here was that the old welding studio had the dirtiest water I have seen to wash the Polaroid negatives after we solarized them. This resulted in a tremendous amount of scratching that, in the end, just adds to the image.

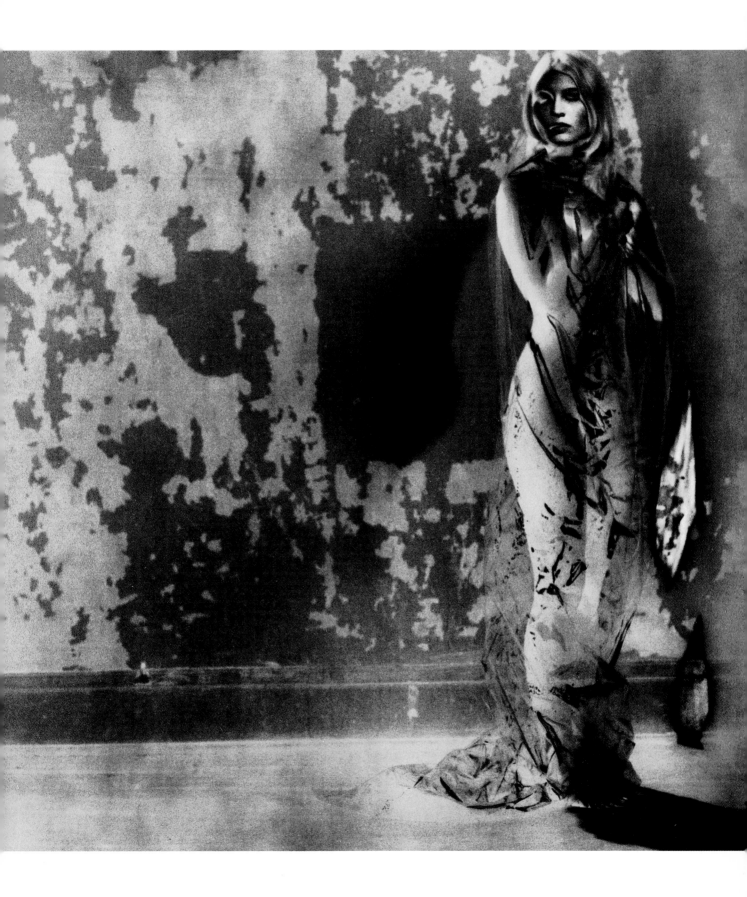

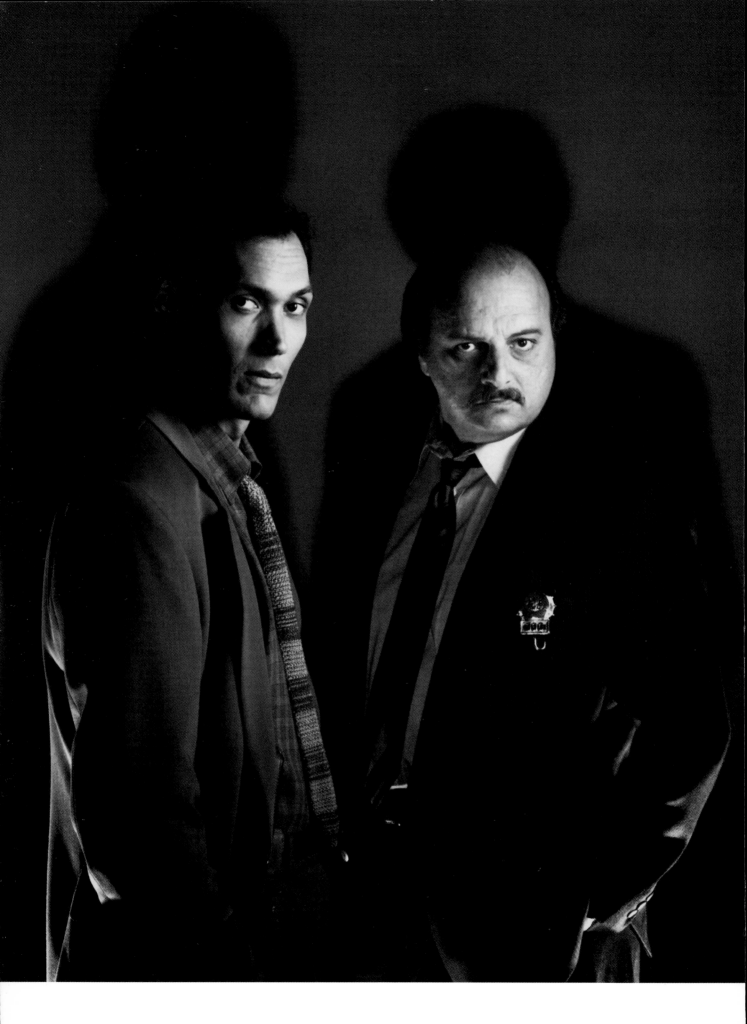

"Be Prepared"

SUBJECT:	N.Y.P.D. Blue
CLIENT:	Entertainment Weekly
LOCATION:	New York, NY
NOTES:	Group Portraits

As a cover story for Entertainment Weekly, I was assigned to shoot the TV show "N.Y.P.D. Blue." Because the show is shot in both New York and Los Angeles, **I would be shooting the cover in L.A., when they were doing their sound studio shooting, and then go to New York to do on-location portraits,** as well as some behind the scenes photos.

For the magazine cover I had rented a sound stage next to the one the show was shooting on. This allowed actors Jimmy Smits and Dennis Franz to walk over quickly and shoot the cover with me between shots on the "N.Y.P.D. Blue" set. **We knew they would have only an hour break in their shooting schedule. In that time I knew I would have to have their grooming (make-up and hair for men) done and shoot two situations.** Plus, I had to allow enough time for them to walk over and be introduced to everyone.

The first situation I set up was a blue paper backdrop with orange construction fencing in front of it. I lit the fence with hot lights so I could create motion in the background. The idea was a play off of the beginning of the show, in which a camera cruises low across a plastic construction fence in New York City.

The second situation was more what I would call a "Grecco." The photo editor, Michael Kochman, wanted me to "do my thing" for the other situation, and I was happy to comply. I set-up a gray seamless paper background and placed my Fresnel strobe directly under my Fuji GX 680 camera. This created a great shadow of the stand-ins we were using to set-up the shot. **I wanted the shadows to resemble an old film noir police movie look, without under-lighting the subjects' faces and making a horror picture out of it.** With this in mind, I cut out two small cardboard circles, taped them to a piece of wire and placed them about a foot and a half in front of the Fresnel strobe. The cardboard

was lined up and manipulated until it blocked the light on the subjects' faces, without changing the shadows on the paper. Next, I lit both of their faces with one softbox with a grid on it. The softbox created nice flattering light on their faces, and the grid kept the softbox from washing out the shadows in the background. Lastly, I needed to separate the subjects from the background, but I do not like the look of a conventional hair light. To break the rules a little, I placed two back lights on the floor behind them, making it a back light/under light situation.

When the actors walked in I was able to quickly move them through both pre-lit situations and get them back to their set on time. For the second situation I shot both black and white and color thinking that the black and white would work well with the noir look I was after.

I wanted to capture a film noir look for this police drama. To do this I under-lit the subjects to create shadows on the background, and back lit them from the floor.

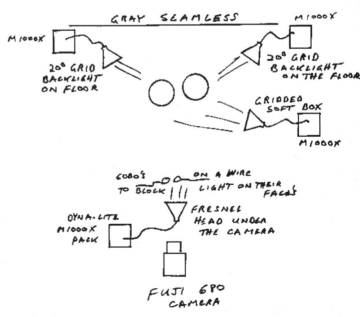

The group shot was done using a near-by Manhattan rooftop while the show was moving from one location to the next. The roof gave me a background of New York, which helped set the scene for the show. The only problem was that the roof was an arduous eight-story walk up, with the last flight having to be made up a straight ladder through a small hole. I knew it would take time for all the cast to get up to the roof and get ready. Their break from the production was half an hour at the most. As a result, everything needed to be fully prepared so I could "coach" everyone up and in position. The challenge was to find enough stand-ins so that we could pre-light the entire shot.

A group shot this large is hard to light in an interesting way; most people tend to use large softboxes. There were too many people to use individual grid spots on everyone, so I used a combination of open heads (nothing on them) to catch several people at once, and some grids, where I needed to keep the light off of other people. **To try to make it different I purposely placed the light where you shouldn't.** The lights were put on the floor, and extreme side angles on some people. I did whatever I could do to add some interest to the lighting.

When everyone arrived it was as I expected – by the time they all got to the roof, got their correct clothes from wardrobe and the make-up touch-ups they needed, it was time for them to go back to filming the show. **I shot the fastest two rolls of film in my life (one black and white, one color) and they were gone.** If you can't tell by now, I'm partial to black and white.

The whole cast had to walk up eight stories and climb a ladder to get on this roof. By the time they did and were all ready, it was time for them to leave. I had to shoot fast!

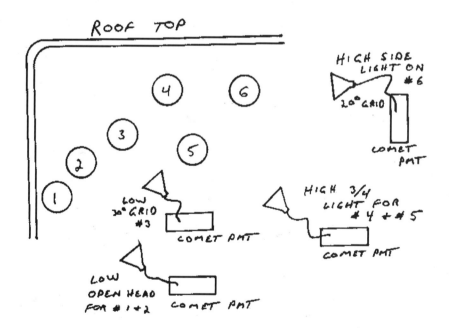

ROOF TOP

4 6

HIGH SIDE
LIGHT ON
#6

20° GRID

COMET
PMT

3

5

2

LOW
20° GRID
#3

1

COMET PMT

HIGH 3/4
LIGHT FOR
#4 + #5

COMET PMT

LOW
OPEN HEAD
FOR #1 + 2 COMET PMT

HASSELBLAD 503CX
80 MM LENS

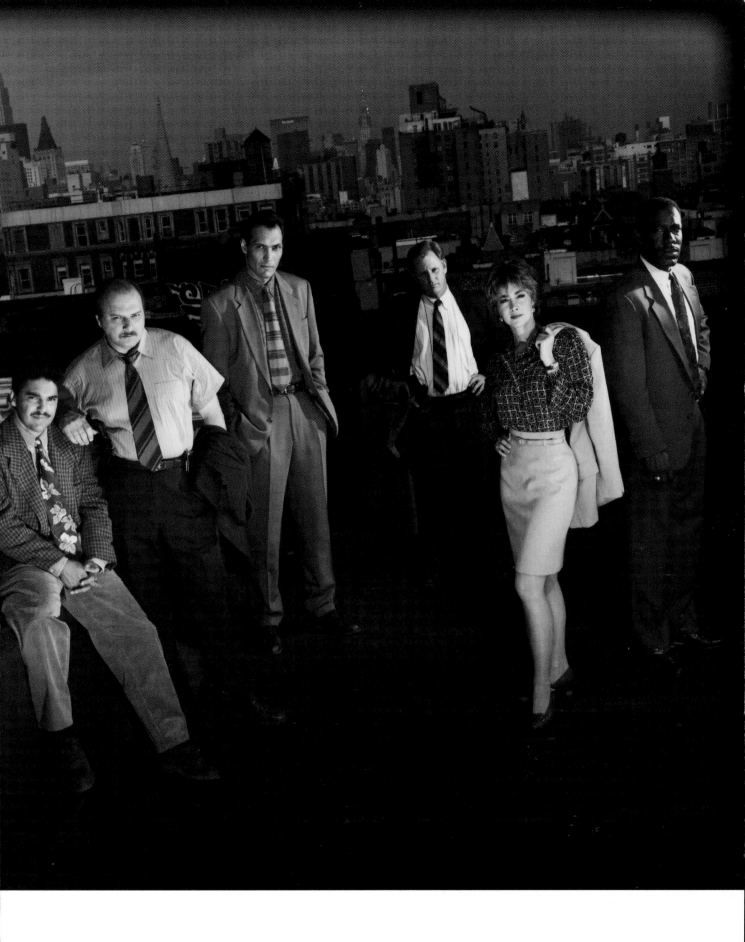

SUBJECT:	X-files
CLIENT:	Fox Broadcasting
LOCATION:	Los Angeles, CA
NOTES:	Smashbox Hallway

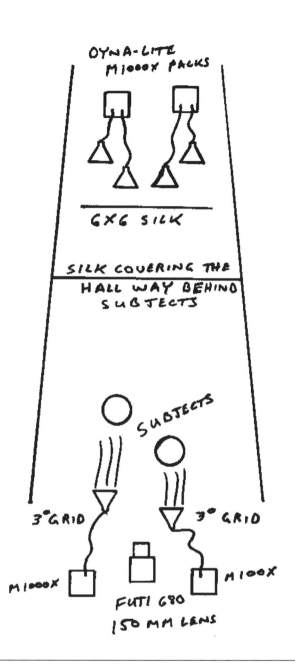

The rear of the hallway was lit for this shot through a piece of silk material. Then I added two 3° grids on the talents' faces to complete the picture.

Gallery Session

I did the first gallery session for Fox Broadcasting's new show "The X-Files." **A gallery is the commissioned advertising and publicity shoot that the networks do.** A shoot like this usually happens once a year, then the resulting images are used throughout the year to promote and advertise the TV show. I had seen the pilot of the show and tried to match the ideas and the style of the shooting to the ethereal subject matter. This particular photo became an identifying image for the extremely successful show, and was used for a poster, billboards and full page ads, in part because we created the appropriate feel with the photography.

On this shoot we worked at Smashbox, the biggest and hottest studio in town. **One of the most interesting areas I found in which to shoot David and Gillian was the hallway between two of the studios.** We had the set-maker bring a piece of silk wide enough to go from floor to ceiling, wall to wall, and get neatly tucked in. I positioned four Dyna-Lite heads behind the silk to back light the subjects very strongly. Because you could see the strobe heads as "star" shapes behind the silk material, I added another 6x6 foot silk and frame between the lights and the main silk, just like a baffle in a soft box. Since there was so much light from behind all I needed to do was to light David and Gillian with two 3° grid spots to complete the shot.

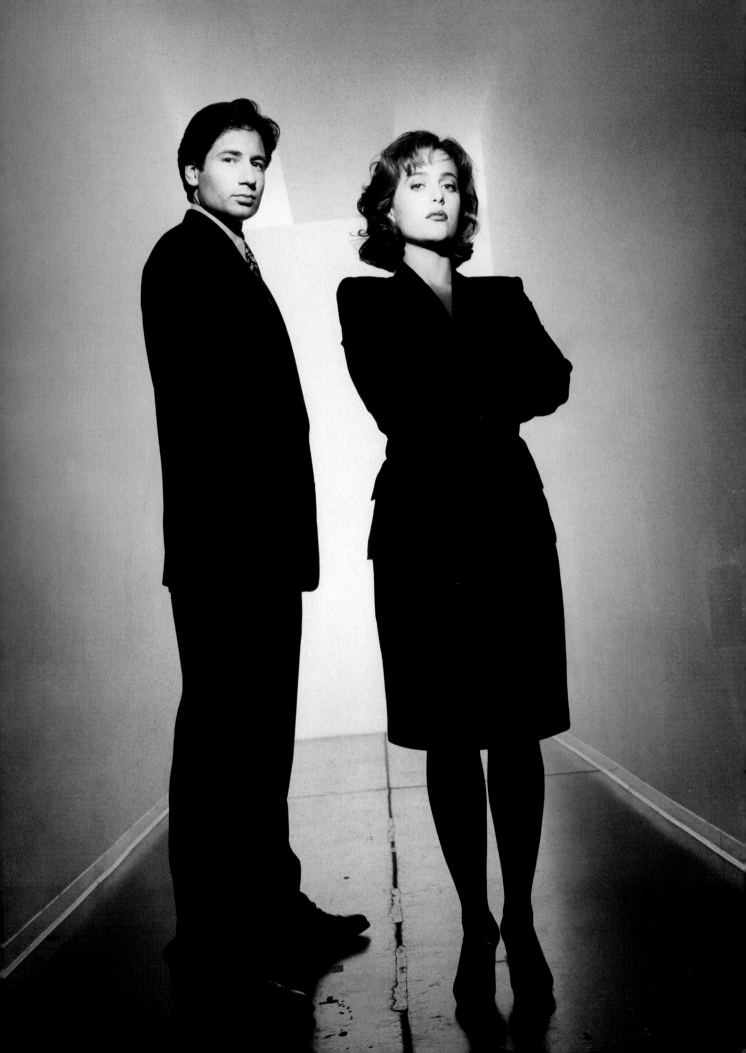

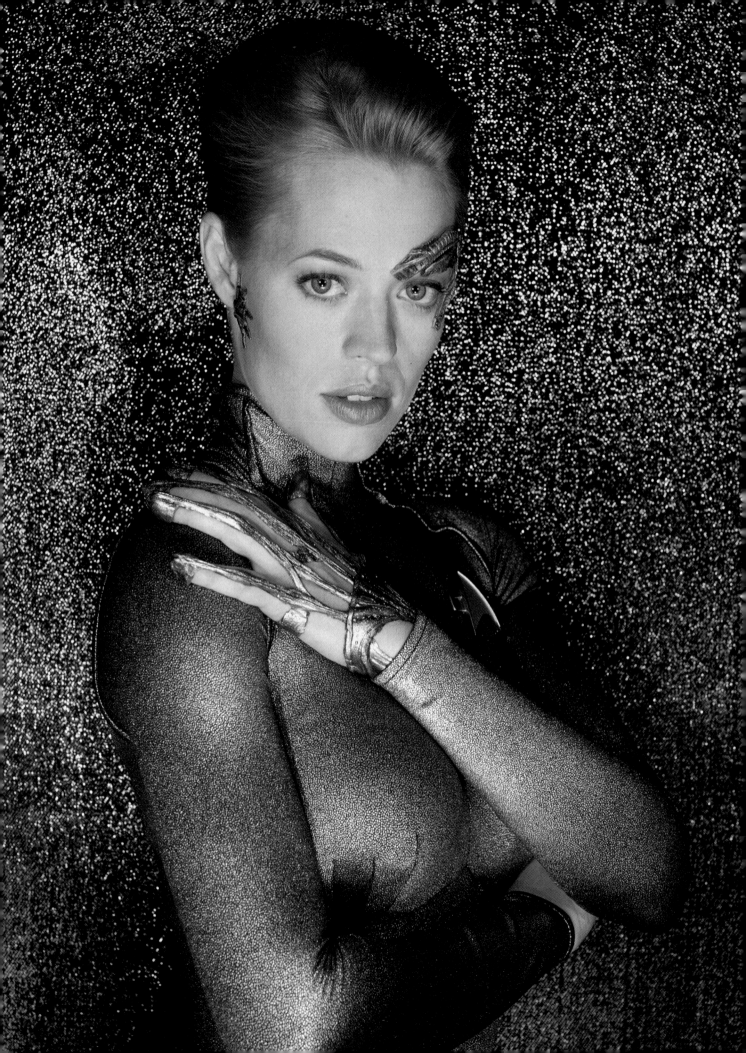

JECT:	Jeri Ryan
ENT:	Entertainment Weekly
TION:	Los Angeles, CA
TES:	Smashbox Studios

This was a cover assignment from Entertainment Weekly. It was shot to highlight a story on the new addition to the cast of "Star Trek Voyager," actress Jeri Ryan, who was photographed in the alien garb of her character "Seven of Nine."

I decided to use fabric as a background. This works especially well for magazine covers, because it easily accommodates cover type by providing lots of clean space around the subject. For this particular shot I knew I wanted a fabric with a metallic thread in it. This helped create an idea of stars that was very appropriate for the image. If you light metallic-threaded material properly, it becomes reflective. This material was black to the eye, but when lit, the light reflected off it like a mirror, it sparkled. **Reflections are like billiards, the light goes into something at the same angle it goes out.** If you light straight into a mirror the light will go straight out. Since the flat or set wall the fabric was stapled to was straight on to camera, I used three grid spotted Dyna-Lite heads with 20° spots to light the scene. One was positioned directly under the lens, and the other two were placed on either side of the lens. This reflected light off both the actress' metallic suit and the background, to create an "other worldly" look.

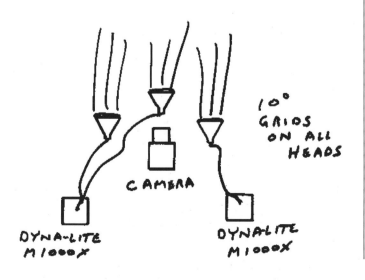

FABRIC ON A FLAT

◯ SUBJECT

10° GRIDS ON ALL HEADS

CAMERA

DYNA-LITE M1000X

DYNALITE M1000X

This was for a cover of Entertainment Weekly. Jeri was in front of a wall with metallic fabric on it and lit with three grid spots. One was just under the lens, with the other two just at lens height on either side of the camera.

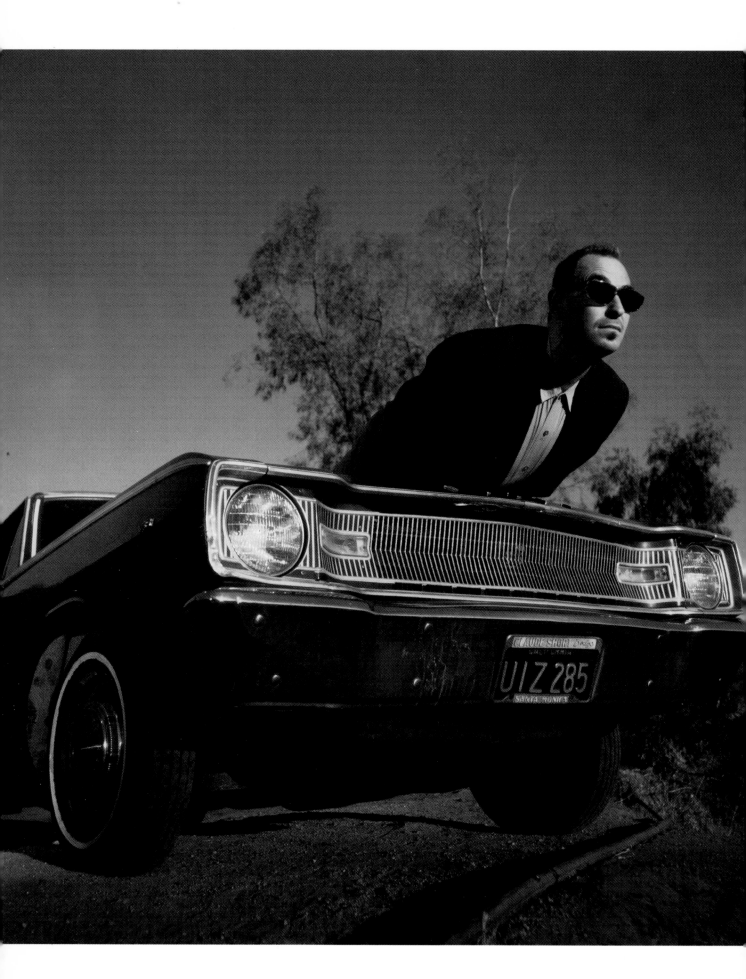

This shot, to me, symbolizes my departure from photo-journalism. Up until this shot I worked to capture reality, but here **I endeavored to create my own reality, and to create the conceptual style portrait I do today.** For a story for Buzz Magazine I was assigned to illustrate a tongue-in-cheek piece by writer and performance-artist extraordinare, Barry Yourgrau. His article was about how phallic and cool his old beat up and junky 1967 Dodge Dart was in Los Angeles, the car culture capital of the world. I immediately had a vision of the writer himself as a hood ornament. We did most of the shoot with other poses and the car, and for the final image I asked him to climb up on the hood and play the role of a hood ornament. Bravo Barry!

I had scouted the location the day before so I knew what to expect in terms of light on the day of the shoot. Fortunately, the natural light had the strong directional quality I wanted. As you can see, **the sunlight catches dramatically on the front and far side of the model's face.** Additional portable lights were used to retain the detail on the side of the car and the tires. The shot was created using a Hasselblad camera with an 50mm lens.

Conceptual Portraiture

SUBJECT:	Barry Yourgrau
CLIENT:	Buzz Magazine
LOCATION:	Los Angeles, Ca
NOTES:	Cross Processed to Chrome

This picture was lit primarily by sun light but was cross processed from color negative to chrome. There was also a magenta gelled strobe on the side of the car.

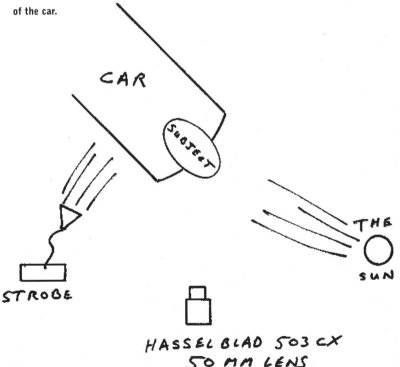

CAR

SUBJECT

THE SUN

STROBE

HASSELBLAD 503 CX
50 MM LENS

As a kid I was always a fan of the **Diana camera. As I developed my own look, I grew to depend often on the dramatic lighting of the strobe. I was very excited when, years ago, I heard about the Holga camera, which has the plastic optics of the Diana, but with a strobe sync.** I had just gotten one when I got the assignment to shoot director John Singleton for the now defunct 'L.A. Style' magazine. Since I am so busy, for better or worse, I usually test new equipment and techniques right on the job, making sure I cover it with something tried and true. I did half of the shoot with the Hasselblad and then decided to give the Holga a try. This was, for the most part, the only frame that worked. The camera does all sorts of funky things including double popping the flash — once as you press the shutter down, then once again as you release it up. I sometimes stick it against my shirt after I press it down to black out the flash as it's released. I lit this subject with just one 10° grid spot on a battery-operated strobe. This shot later became a double page spread in the year end issue of Entertainment Weekly.

The Holga Look I

This shot was made with a $10 plastic Holga camera. The camera was used throughout the shoot, which was also shot with a Hasselblad.

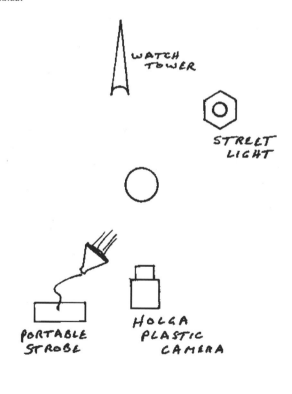

SUBJECT:	John Singleton
CLIENT:	L.A. Style
LOCATION:	South Central Los Angeles
NOTES:	Holga Camera & Grid Spot

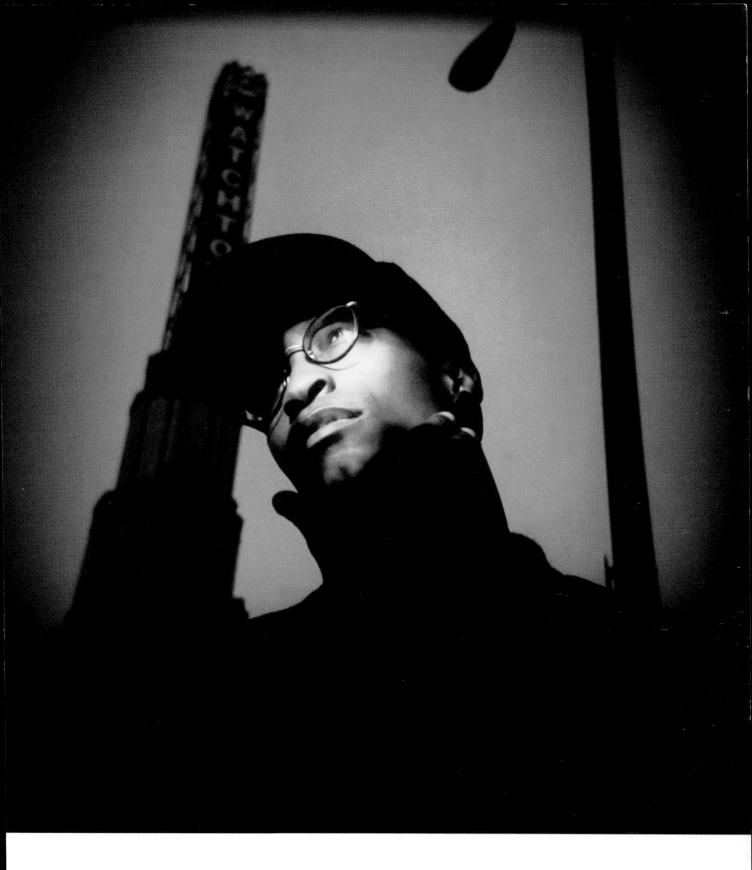

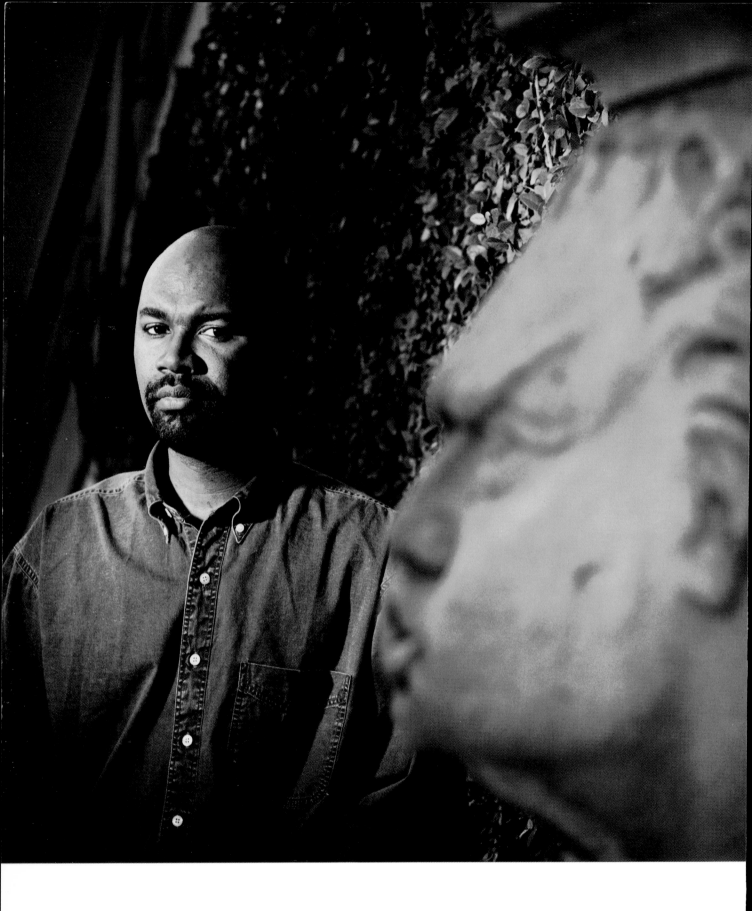

After the picture of John Singleton ran in L.A. Style and Entertainment Weekly, designer Gary Keopke saw it and wanted to use it in a new magazine he was designing called 'Vibe.' He had two other people to shoot for the same story in which the John Singleton photo was to be used, and wanted me to do them all in the same style. I knew I could not rely on the Holga's one shutter speed and two f-stops to shoot the other two subjects, so **I devised a way of putting black tape over the Hasselblad lens shade to give me the ability to create the characteristic Holga black vignette, but with all the shutter speeds and f-stops. This became my style for my black and white work for many years.**

The Holga Look II

For the writer Nelson George I found a great fountain across from his hotel to use as a location. **I wanted to match the drama of the environment captured in the John Singleton photo, so I used the head of the fountain in the shot.** Because the head was so white and Nelson is fairly dark skinned, I only lit him with a 10° grid and let the background (or ambient light) fall at least two stops below the 100 ASA Polaroid exposure (f/11). Then, when I shot the Tri-X (400 ASA) I closed down one stop and even pushed the film 1/2 stop to give me good contrast on the negative and keep the dramatic tone. My images are often printed as a partial sepia tone on fiber based paper.

The statue in the foreground was used for drama. Because it was white, it was not lit by strobe. I used a high shutter speed to underexpose the ambient light by two stops.

SUBJECT ← (circle, top of sketch)

BARE HEAD
CLOSE IN

PORTABLE
STROBE

SCULPTURE

STONE
WALL

HASSELBLAD
503CX 80MM LENS

SUBJECT:	Nelson George
CLIENT:	Vibe
LOCATION:	Los Angeles, CA
NOTES:	Hassi to Look Like Holga

This shot was taken to document LL Cool J's emerging film career. He was going to be in the movie "Toys" with Robin Williams. Looking for a backdrop to set the tone, I drove to Los Angeles and found this great sculpture in Culver City, CA, of movie film constructed of brushed steel. **Rather than simply using what I found as a literal message, I looked for an angle on it where the sun actually reflected off of it.** This made it skip light back into the camera. Using the Hassleblad's 1/500 second sync speed and a strobe at about f/16, I was able to make almost everything go dark and dramatic except his face and the reflection off the metal. As in the previous shots, I put black tape around the lens shade of the camera to mimic the effect of the Holga.

The Holga Look III

I shot the sculpture from such an angle that the sun reflected off of it, making it very graphic. I lit the subject with a tight grid in order to add just his face to the "graphic" of the background.

METAL SCULPTURE

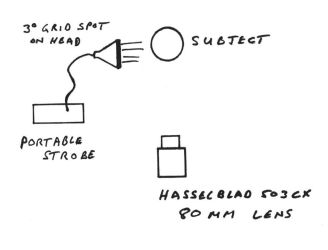

3° GRID SPOT ON HEAD

SUBJECT

PORTABLE STROBE

HASSELBLAD 503CX 80 MM LENS

SUBJECT:	L L Cool J
CLIENT:	Vibe
LOCATION:	Los Angeles, CA
NOTES:	Hassi to Look Like Holga

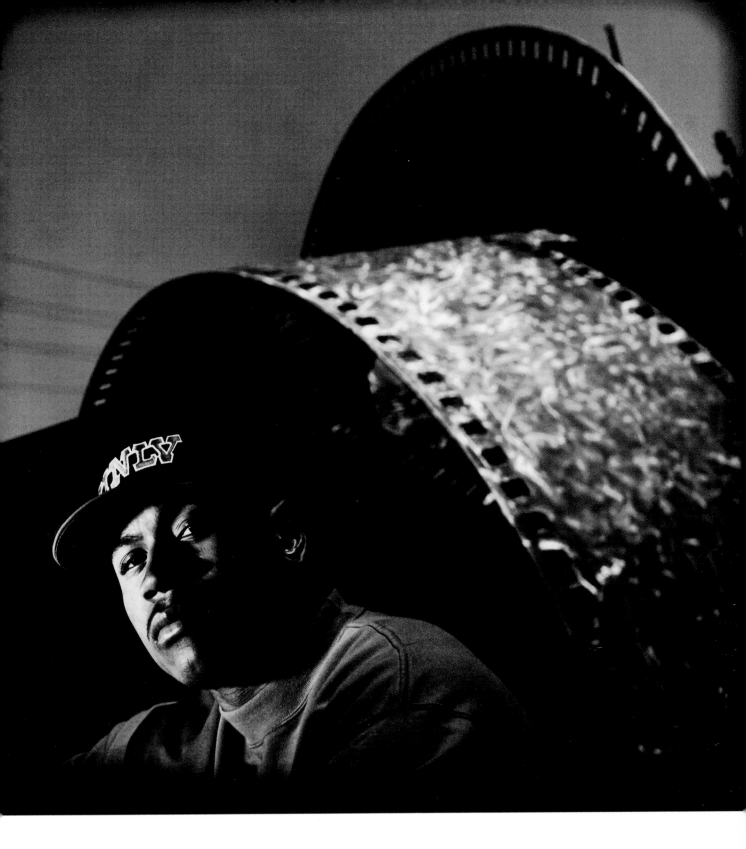

After I did the story for Vibe, the style inspired me to do this next story. I woke up from a dream and I saw these jewelry images in my head.
I did not know if I would shoot it as a hair oriented story, but I described the images in my head to the art director of the Los Angeles Times Magazine and asked what she thought. She took my concept to the fashion editor and then came back to me and asked if I could make my vision work with the twisted metal wire style of jewelry that was popular at the time. I thought it would be a great idea.

My original description of the images was for the model's hair to be twisted, and wild light to be used with **the sort of edge-vignette look of the Vibe story.** Since the jewelry to be used also had a twisted look I wanted the light to have the same feel. For this shot (above) two hot lights were used on either side of the background and aimed through cookie boards to make most of the patterns on the wall. Cookies are wooden boards of various sizes with holes cut out of them in different shapes. In the center of the wall I projected a little out-of-focus pattern of light, using an optical spot attachment on my Dyna-Lite Head. This attachment is like a little slide projector that fits over the top of the head and can project either a slide or a metal theatrical pattern. To play on the Biblical image of the crown of thorns, we put the necklace on top of the model's head. To accentuate that, the light for the model was set very high above her to create a shadow over her face. As I said, I do a lot of things by feel, and often don't have a logical explanation for it. The last touch that works so well for this picture is the white mascara the make-up artist used on the model's eyelashes.

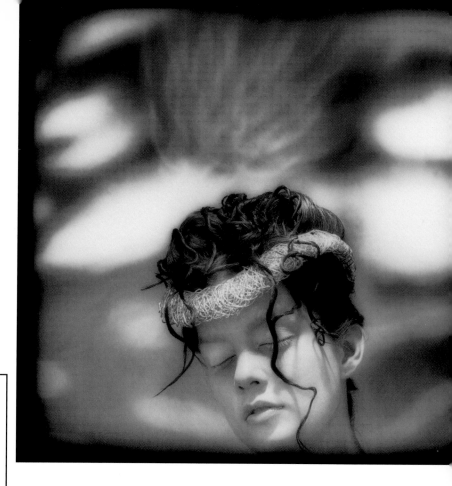

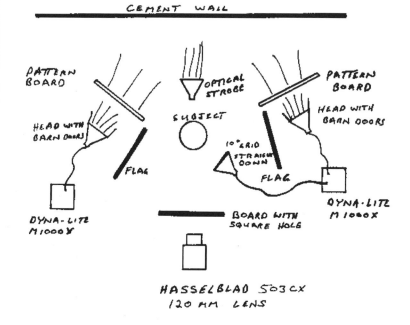

I originally dreamt these images and used light to recreate my memories.

The Holga Look IV

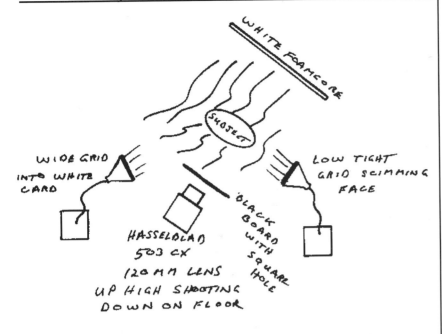

WHITE FOAMCORE

SUBJECT

WIDE GRID INTO WHITE CARD

LOW TIGHT GRID SKIMMING FACE

BLACK BOARD WITH SQUARE HOLE

HASSELBLAD 503 CX
120 MM LENS
UP HIGH SHOOTING
DOWN ON FLOOR

For this shot (below) I wanted the piece of jewelry to look like a mandala. For this reason it was placed on the forehead (or "third eye" point) of the model. The model lay on a piece of material on the ground. I wanted her to be almost upside-down so I shot her from the top of her head. To be different but consistent with the other shot, I set the main light very high above her. This put deep shadows in her eyes. For a fill light, I bounced a strobe head into a piece of white board from the other side of camera. This filled the shadows on her face but still leaves some shadows for drama. **The original prints for this story were copper toned and diffused in the printing. I do not like to add diffusion when shooting, because it softens the whites, but in printing it takes the edge off just the blacks.** This added to the dream-like quality of the photos. Because these shots were done with longer lenses (the masked lens shade was too far out of focus), I vignetted the frames with pieces of black board in front of the camera. The board had a square cut out of it with rounded corners.

I placed the face light very low to make the light on the subject's face shadowy.

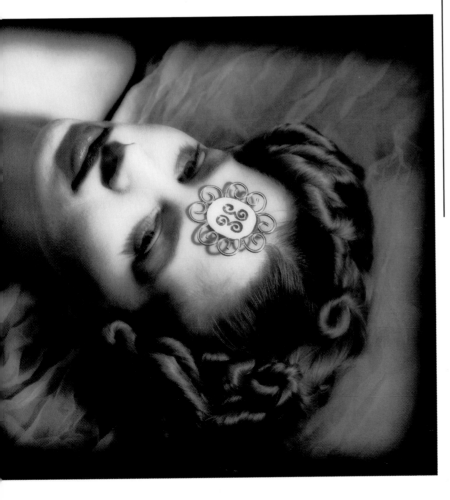

SUBJECT:	Jewelry Story
CLIENT:	L.A. Times Magazine
LOCATION:	Los Angeles, CA
NOTES:	Hasse to Look Like Holg:

This photo of Richard Branson was for a special issue of Business Week called "Enterprise." **I had to do ten full-page portraits of the most important entrepreneurs of the time from all around the world.** The magazine had seen the "Holga-esque" photos I had done of John Singleton and LL Cool J, as well as the jewelry story I did for the L.A. Times Sunday Magazine. The director of photography, Larry Lippman, and his associate, Scott Myln, and I discussed how we could translate that look photographically to ten business portraits. **The following pictures resulted from that assignment.**

When I got to Richard Branson's place in London the first thing I saw was this incredibly ornate mirror in the hall. The cherubs sort of brought to my mind the idea of the virgin of Virgin Airlines — as I said some of my concepts are abstract. I then found an airline award he had gotten that was a big airplane on a stand. We quickly pulled it apart (I always bring some tools with me) and I came up with this shot. The mirror was hung high, so Richard had to stand on a box to fill the frame nicely. I stood far enough away from him so I did not see myself in the mirror. I lit the mirror, and him, with grid spots. **As I was shooting, I asked him to look up and "fly."**

I was squeezed in a hallway for this shot, trying not to see myself or my lights which were tucked in very close to the subject and the camera.

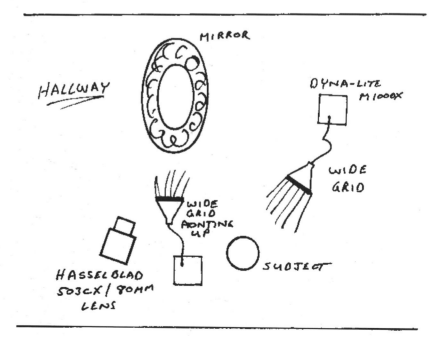

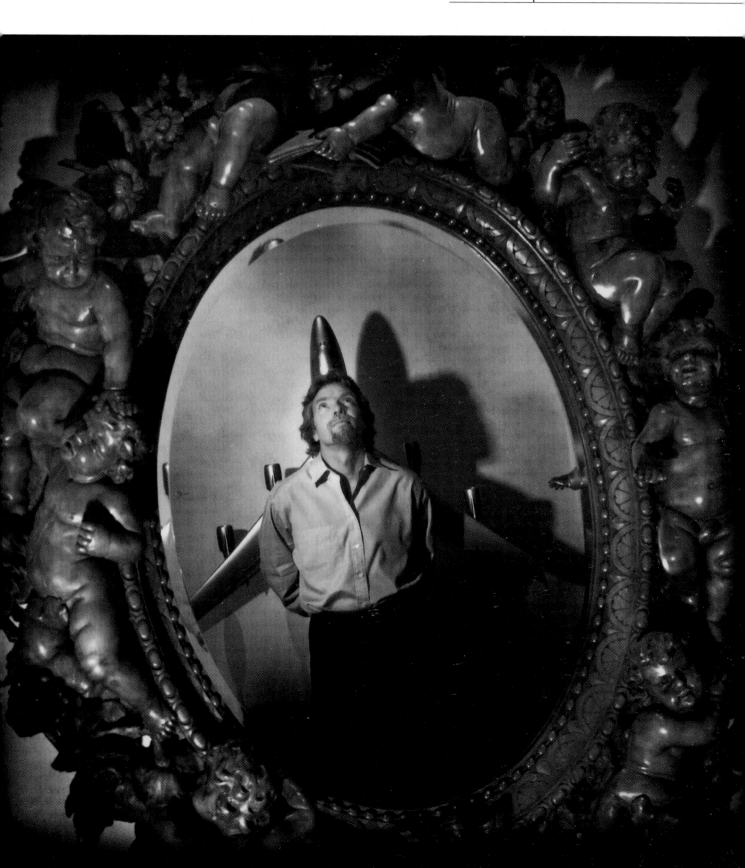

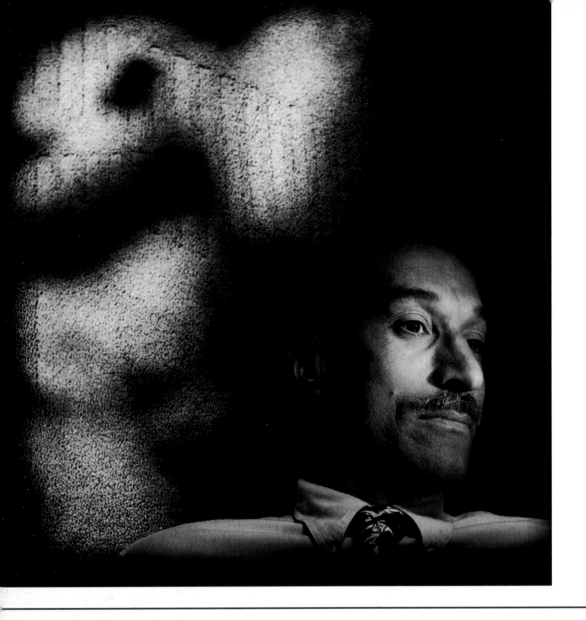

I had the
CEO of
New Balance
shoes lay on
a rug with his
logo on it
and lit his
face.
I then ran a
hot light
through a
plant in the
office to
break up
the logo.

This is **Jim Davis, the president of New Balance Shoes.** To shoot this image, I had him lay on a carpet that had the subtle logo of New Balance on it. Again, I don't want to be literal with my story-telling of who these people are, I like to leave some mystery to it. To light the logo so that it was not too legible, I ran a Lowel tungsten hot light through a plant to break up the light. This is my very expensive and heavy "plant gobo." I usually pick them up at the location and then leave them there. After all, it's pretty difficult to get on the airplane with a 300 pound plant!

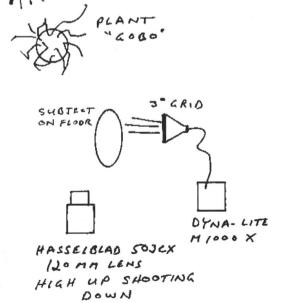

HOT LIGHT WITH BARNDOORS

PLANT "GOBO"

SUBJECT ON FLOOR

3" GRID

DYNA-LITE M1000X

HASSELBLAD 503CX 120 MM LENS HIGH UP SHOOTING DOWN

This whole shot was done in the white walled corner of a conference room, making effective use of shadows and light. As one of my lights, I used a slide projector on the wall.

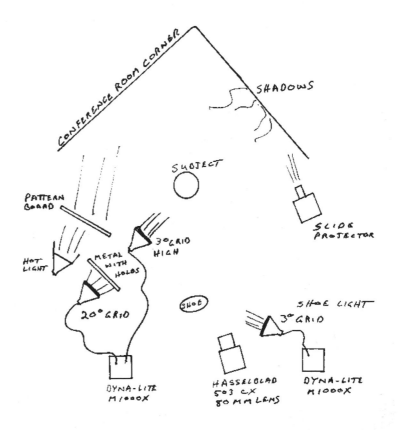

This shot was taken in the corner of a conference room with two white walls. It is a photograph of **Sheri Poe, the CEO of Ryka Shoes.** When I arrived I had no idea what I was going to do, and the natural environment gave me little to work with. The staff at Ryka brought me a slide projector with some shots of their products, but that was too literal for me. I opted to create the shot from scratch, since I had plenty of time to set it up. A side note: **when I arrive at a shoot I usually discuss what I expect the subject to do and what I need in terms of time. I also ask the subject for his or her time constraints.** Sheri had no time constraints, since she was going to be in all day with no meetings.

This whole shot was done with one prop (a running shoe in the foreground) and light and shadow on the walls. **I took their slide projector and used it to put a slash of light across the wall from the right side.** I then pulled out one of the metal cookies I always pack for shoots. This piece of metal has round holes in it that reminded me of the bottom of running shoes. I placed Dyna-Lite Head with a 30° grid spot on it below Sheri's face and to the left of the frame. This meant that it basically hit only the wall to camera right. I then lit the wall on the left side of the frame with a patterned gobo (or cookie) from the extreme right side. Finally, I lit the subject's face and the running shoe with 3° grid spots. Her face light was set high to produce the double shadows of her on the wall. The light for the shoe was put on the ground to light it from underneath.

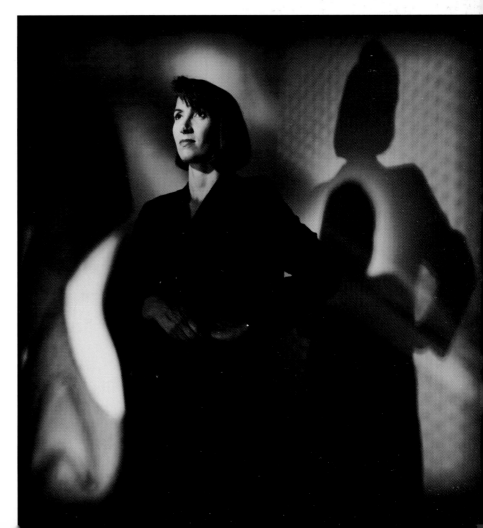

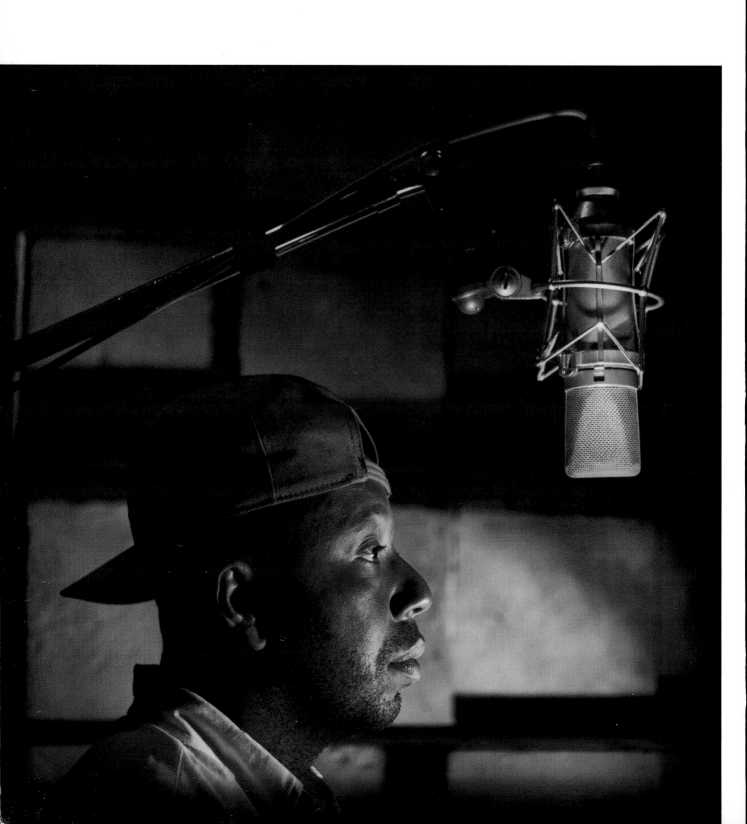

Business Portraits IV

This portrait of Russell Simmons of Def Jam Records was done in a recording studio for obvious reasons. **The interesting thing to me about this image is that although it does not look like scary "Halloween" lighting, every light in this shot is set close to the floor.** The microphone is lit from underneath to separate it from the black wall. The wall was lit from below with a hot light to project shadows of its tile-like texture up the wall. Even Mr. Simmons was lit as far below as possible, without making him look scary. Why all the under light? **If I had to analyze it I would say I like breaking the rules, but I don't start out thinking about it that way.** I start out wondering how I can make an interesting picture that's different.

Every light in this shot is placed low, either below the camera or on the floor to give an interesting overall look.

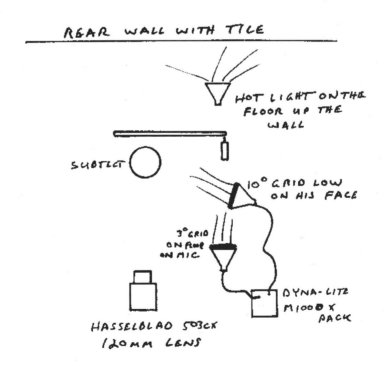

REAR WALL WITH TILE

HOT LIGHT ON THE FLOOR UP THE WALL

SUBJECT

10° GRID LOW ON HIS FACE

3° GRID ON RIM ON MIC

DYNA-LITE M1000X PACK

HASSELBLAD 503CX 120MM LENS

When I walked into the Dallas hanger for Southwest Airlines I fell in love with the airplane engine shape and the little squiggle in the center of the engine. I have seen airline CEO's shot in airplane engines before, so my job here was to figure out how to do it differently enough to make the shot my own. I had also done a great deal of research on Herb Kelleher the CEO of Southwest Airlines, and knew he was a fun guy and would do almost anything. Since I like to do the opposite of what's expected, I decided to flip this subject around and have him upside down. He liked the idea. I lit the engine with one Dyna-Lite head with a 40° grid spot, and lit his face with a 3° spot from a C-stand arm above the engine.

Since the client loved the jewelry story I did, I wanted not only to light the pictures dramatically, but to mimic some of the unusual positions of the models. So, just to be different, I asked Herb if he would go upside down in the engine.

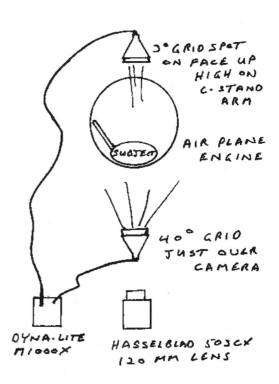

3° GRID SPOT ON FACE UP HIGH ON C-STAND ARM

AIR PLANE ENGINE

SUBJECT

40° GRID JUST OVER CAMERA

DYNA-LITE M1000X

HASSELBLAD 503CX 120 MM LENS

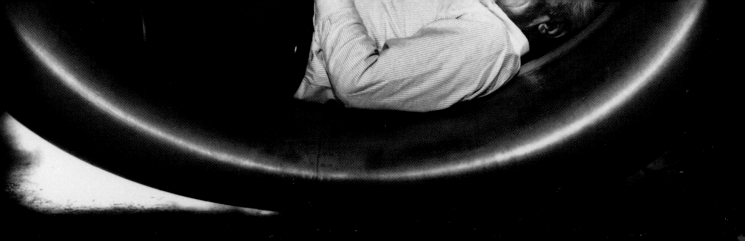

Long Exposures

WALL

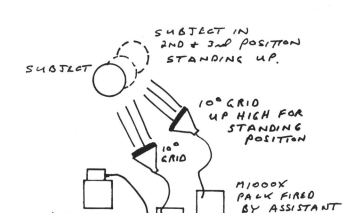

WALL

SUBJECT

SUBJECT IN 2ND + 3rd POSITION STANDING UP.

10° GRID UP HIGH FOR STANDING POSITION

10° GRID

M1000X PACK FIRED BY ASSISTANT

HASSELBLAD 503CX

DYNA-LITE PACK "SUNK" TO CAMERA

Sometimes things really snowball. **Worth magazine saw the Business Week story and put me on the road shooting seven conceptual portraits of everyday investors. The concepts had to be tied to their investment philosophy.** This woman's philosophy was, "Lose your ego as a investor, and don't be afraid to ask questions." This photograph was an experiment with multiple flashes going off during the exposure and was the precursor to the double-face portrait of Al Jourgensen on page 16. To get the idea of losing her ego in this double image, I set up a 10° grid on her and left the shutter open for about three seconds. After the flash went off, and while the shutter was still open, I had her stand up. I had a separate head and grid spot on a separate Dyna-Lite pack that I fired from the pack when she was in the right position. The flash head was set a stop below the camera exposure to make the second image ghostly.

I wanted the feeling of the subject "losing her ego" for the story, so I had her stand up during the exposure and popped off an additional strobe during her movement.

SUBJECT:	Portrait of Investor
CLIENT:	Worth Magazine
LOCATION:	Birmingham, AL
NOTES:	Multiple Flashes

SUBJECT:	Jack Rosenzweig
CLIENT:	Worth Magazine
LOCATION:	Pennsylvania
NOTES:	Portable Strobe and the Holga

From Alabama we traveled to Pennsylvania to photograph an investor whose quote for the story was "enjoy" (investing). So when I got there I spent a good amount of time with him asking him about his life and what he does. He gave us a tour of his ranch and house in Pennsylvania, showing us all his toys. He liked to fly planes and ride motorcycles.

When we got to the motorcycles I knew what I was going to do with him. My assistant, Jason, and I actually rolled the bike out on to his grass airstrip to get the right environment for the concept of "enjoy." I also wanted him to be posed differently, not just sitting on the bike. **Sitting and relaxing at the front of the bike in silhouette seemed to convey the concept.**

It was a very cold day so we worked fairly quickly before the sun set and it got even colder. I set up one Comet PMT battery powered head and pack in front of him to light his face without flat lighting the entire scene. The shape of the motorcycle works well without having to blast it with light and "record it." **At one point the sky exposure was perfect to try shooting this shot with my Holga plastic camera. Remember, it has a fixed shutter of about 100th of a second.** As it turned out the Holga shot was the one we loved.

Finding the Environment

OPEN HEAD

COMET PMT

SUBJECT MOTOR CYCLE

HOLGA CAMERA

The outside light was dark enough for me to use my Holga camera. To make it more dramatic, I lit the subject from past the side (almost 3/4's from the rear) with a portable Comet Strobe.

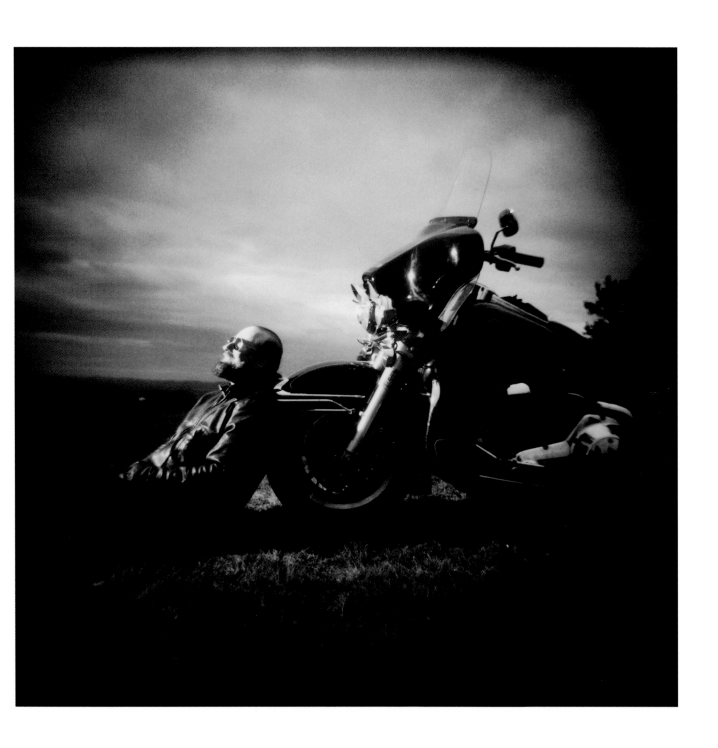

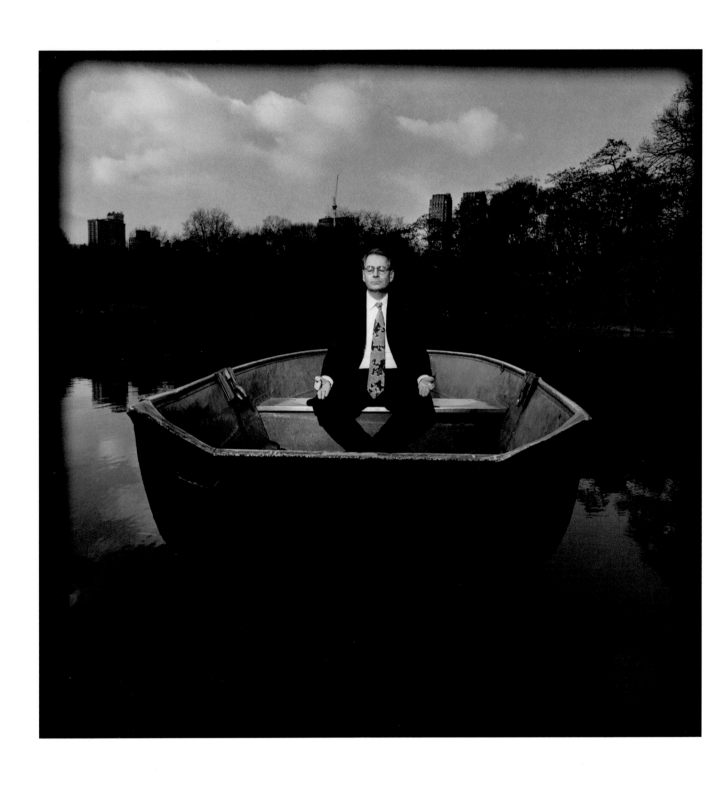

Getting this shot done became a series of very funny circumstances. **This investor's quote or philosophy was "have inner calm no matter what the market does – you're in it for the long haul."**

My first idea for "inner calm" would have been to put him in a Japanese Zen Garden. The first one we found in New York City was at an official Japanese building and the day we wanted to shoot they had a visiting dignitary. The magazine found another Zen Garden, but that was closed for renovations. **Between the photo editor and myself we checked out about six places and they were all unavailable – it's tough getting a piece of inner calm in New York.**

The photo editor and I finally put our heads together and came up with shooting the subject in a boat on the pond in Central Park. **I explained the concept to our subject and he had the easy job of just sitting there and looking like he was meditating.** I, on the other hand, had trouble keeping a continuously moving boat and subject in focus with a medium format camera, especially since I was trying to light it and compose it at the same time. To take away one of the variables (the boat moving) we tied fishing line (always carry some) to the corners of the boat and tied the boat to the dock. This helped immensely. **Suddenly I had inner calm, too!** The shot was lit with one Comet PMT head and shot on Tri-X.

SUBJECT:	Isaac Zisselman
CLIENT:	Worth Magazine
LOCATION:	New York, NY
NOTES:	Boat in Central Park

To keep the boat and the subject from floating away we had to tie the boat down from the corners with fishing line.

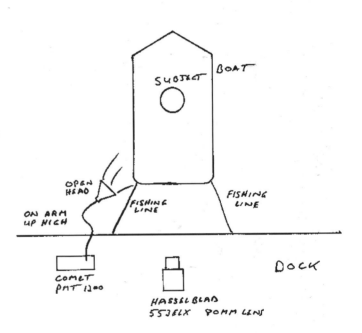

Finding the Environment II

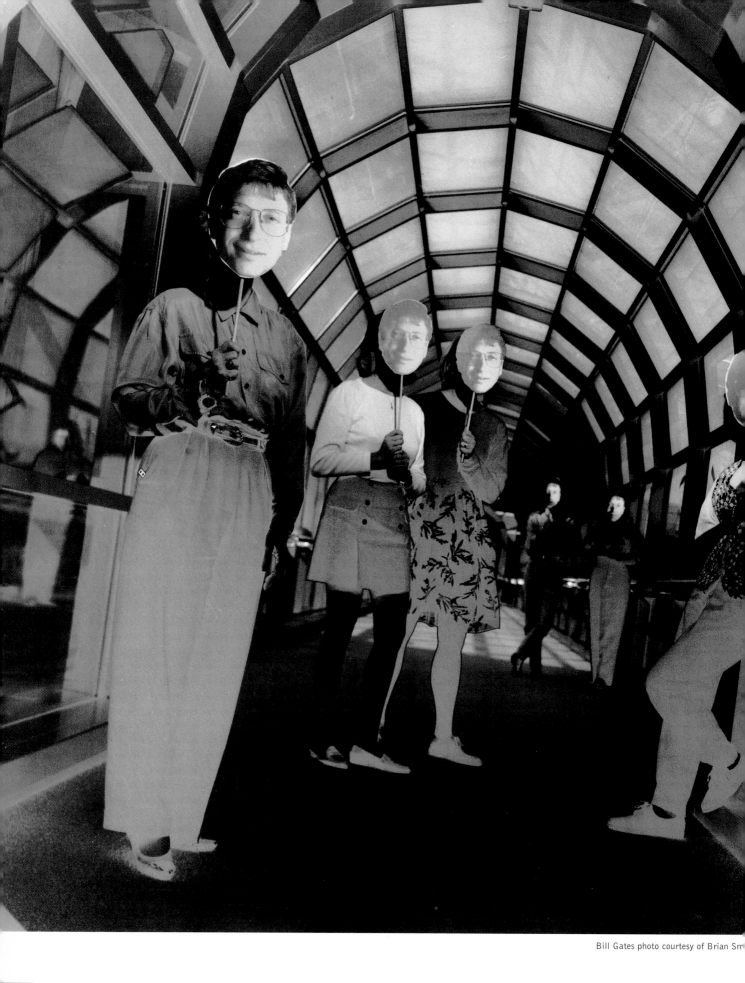

Bill Gates photo courtesy of Brian Sm

Art Directors

This was a cover story for Fast Company called "The Women of Microsoft." **The art director, Patrick Mitchell, came up with the idea of the Bill Gates masks. At the time, I didn't know if the masks would work or not, but as you can see in the end it did. Working with imaginative art directors is great!** I shot the picture both with the masks off and the masks on. The shot with the masks was used as the cover and a full single page opening to the story. Then as you turned the page there was a second "surprise opening" spread without the masks and everyone in the same position. The layout really made effective use of a fun series of pictures. This image was made by solarizing Polaroid 665 positive/negative film. The people were lit with 3° and 10° grids above the left and right of camera.

The lights for this shot were placed just over camera. The difficult part of the shoot was keeping the reflections off the Bill Gates masks.

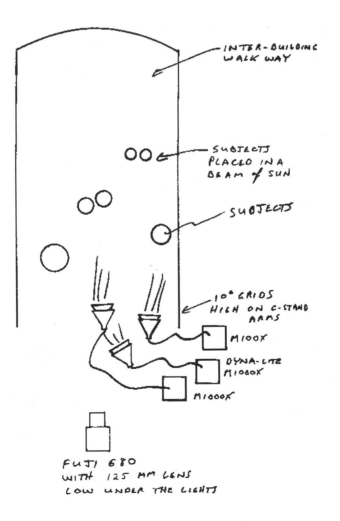

INTER-BUILDING WALK WAY

SUBJECTS PLACED IN A BEAM of SUN

SUBJECTS

10° GRIDS HIGH ON C-STAND ARMS

M100X

DYNA-LITE M1000X

M1000X

FUJI 680 WITH 125 MM LENS LOW UNDER THE LIGHTS

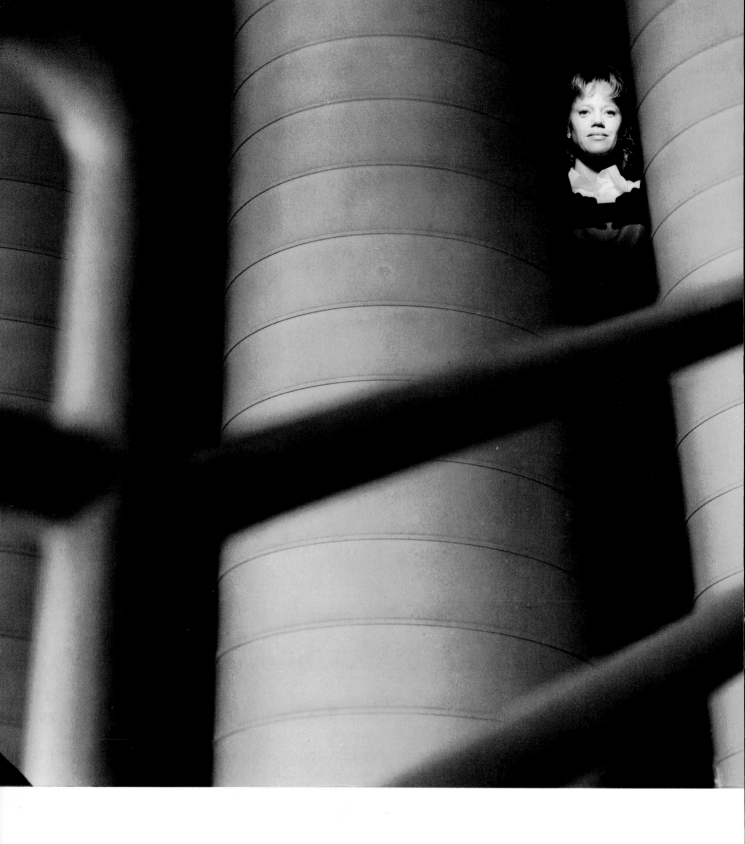

I hid the light stand behind the air duct and put the grid spot was just above the frame on a C-stand arm. I love the proportions of this image, with the subject as a small face in a sea of machinery.

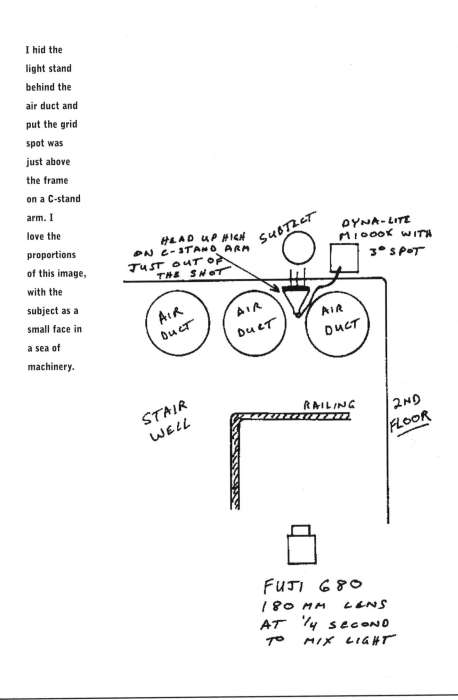

HEAD UP HIGH ON C-STAND ARM JUST OUT OF THE SHOT

SUBJECT

DYNA-LITE M1000X WITH 3° SPOT

AIR DUCT

AIR DUCT

AIR DUCT

STAIR WELL

RAILING

2ND FLOOR

FUJI 680 180 MM LENS AT ¼ SECOND TO MIX LIGHT

Art Directors II

Not to sound flippant but this shot was achieved simply by opening my eyes and looking around. **The Microsoft campus is very sterile, photographically speaking. The previous photo of "The Women of Microsoft" was shot in what I considered the most interesting location there, a walk bridge between buildings.** For this shot I used the railing of a stairwell as the foreground and put the subject (another woman of Microsoft) behind a set of air ducts. If you were not "squinting" and imagining the possibilities you probably would have missed it. The subject was lit with one 3° Dyna-Lite grid spot on a C-stand arm between the subject and the air duct. The stand is hidden behind the duct, and the light and arm are overhead, just out of frame.

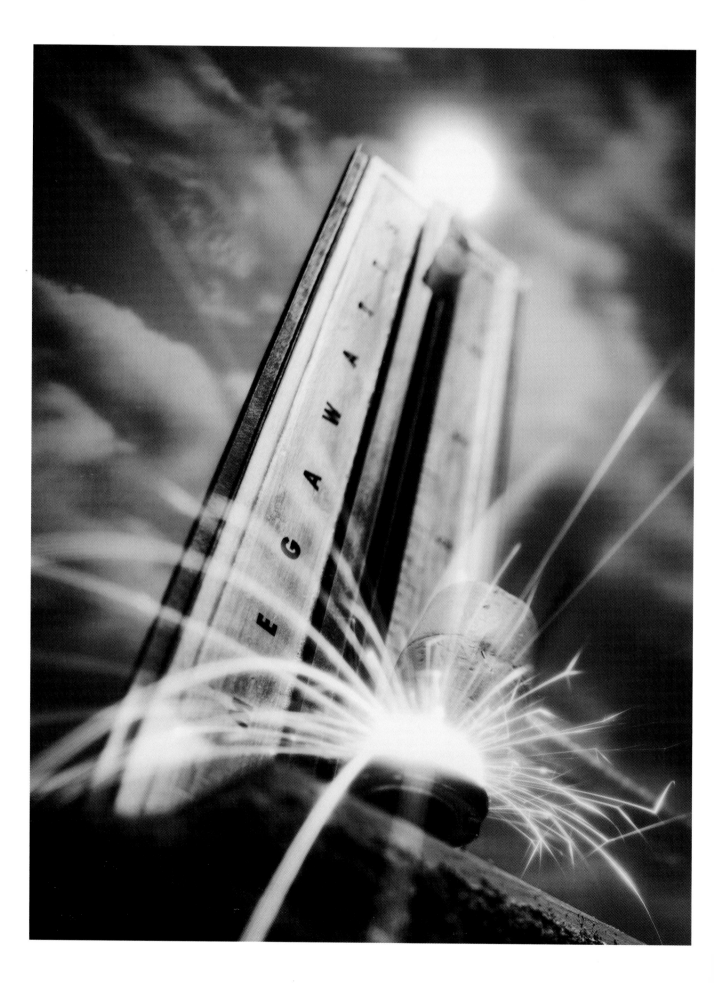

Concept Continuity

I got a call one afternoon from a potential client who had seen my work and said that he had to shoot an annual report for an electric company. He told me what they were thinking of doing for the shoot, then asked me what I thought about their idea and how I would handle the rest of the job. Their idea was to put the president of the company behind his desk out in a field with electric wires behind him. I liked the idea, but could not figure out how to continue this with four more people. As I was on the phone, I paced the floor and talked my way through the entire annual. **I suggested we shoot everyone on a podium that symbolized what he or she did for the company.** The president could be on the highest tier of a sports medal platform with power lines and a transformer behind him. The man who builds the plants could stand on cinder blocks with sand around them in an empty field with a trowel in his hand. The accountant could be shot on a classic Greek column with an abacus in her hand in a classic garden.

Because this shot is made up of four separate exposures, after a hard day of shooting I had only three or four rolls of film to show for it.

SUBJECT:	Strongman Model
CLIENT:	Calpine Corp.
LOCATION:	San Francisco, CA
NOTES:	Spark Generator, in Studio

This is the shot for the cover of the annual report. **I know it's not a portrait, but it was so interesting to light that all the technophiles can be technophiles with this one.** The shot is of a model of one of those strong man games at a midway or carnival – an electric version, of course, to symbolize the power company. When I was told about this idea from the design firm I said "That's great, but when the hammer hits the plunger it has to spark." They loved that idea.

The image is actually four different shots on one piece of film. The shutter was left open so that the camera would not have to be wound over and over again, avoiding the chance that the film might move. The first exposure was of the hammer coming down on the pad to make the sparks. I had the model maker put a spark generator at the contact points. We raised and lowered the hammer with string until we got enough sparks. Then I turned on a very narrow beam on a hot light and slowly raised the hammer up to give the hammer a blur. Firing the strobes that lit the model and the painted sky backdrop made the next exposure. Lastly I dropped a soft focus filter over the lens and turned on the light bulb at the top of the model and burned it in for a few seconds. I love this shot.

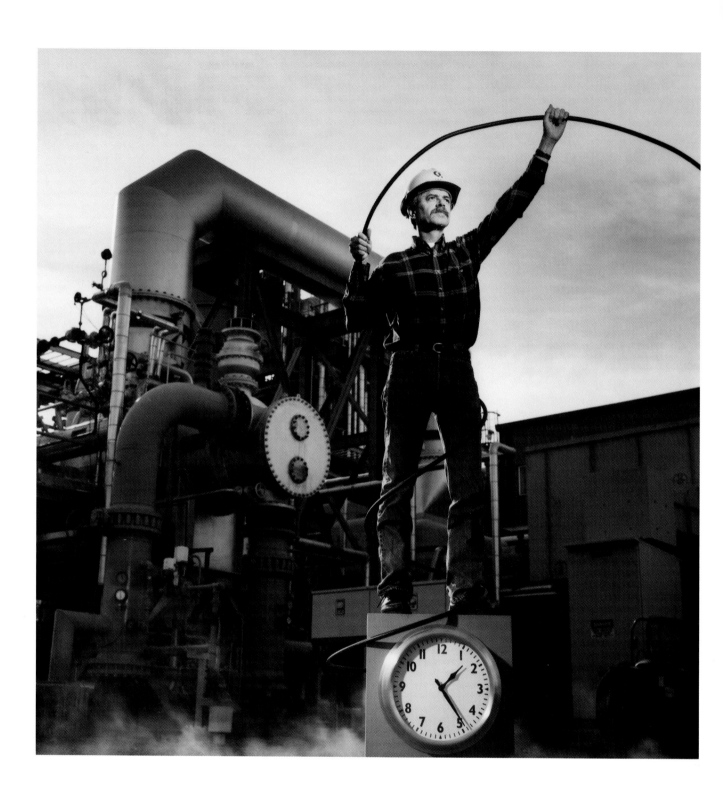

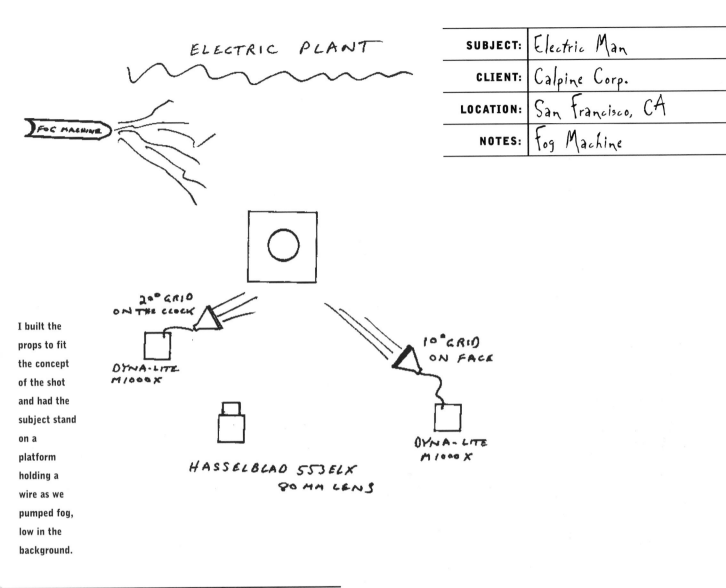

ELECTRIC PLANT

SUBJECT:	Electric Man
CLIENT:	Calpine Corp.
LOCATION:	San Francisco, CA
NOTES:	Fog Machine

FOG MACHINE

20° GRID ON THE CLOCK

DYNA-LITE M1000X

10° GRID ON FACE

DYNA-LITE M1000X

HASSELBLAD 553ELX 80MM LENS

I built the props to fit the concept of the shot and had the subject stand on a platform holding a wire as we pumped fog, low in the background.

This man is responsible for keeping the electric plants running 24 hours a day, 7 days a week. To symbolize this **we brought him to an electric plant and wrapped him in a coil of wire.** On his podium we added a clock and some fog on the ground. With the sun behind him I added a grid spot to his face and a second to the clock below him.

Selective Focus

For this shoot of tennis great Michael Chang, after I did an action portrait, I wanted to do a secondary shot. This was shot for Men's Health and I knew that a secondary shot could be used either on the table of contents page or as a "jump" page picture. For the portrait, we shot Michael full figure, swinging his racquet into the lens. To make the shot a little different **I wanted to go in a graphic direction using the pattern of the racquet and having his face out of focus.** After all, we were going to see his "action" portrait as a full-page lead photograph to the story.

The accompanying set photograph, with my assistant Jason Hill manning my Hasselblad, shows how the shot was set up. Because I did not want to light the wall in the background, I needed to mix the ambient room exposure with my flash. However, when I slowed the camera shutter speed to get a little bit of the back wall on the Polaroid, I had too much light on the subject. So I used a 6 by6-foot black nylon panel to block the light over his head. Now I was free to use a shutter speed I needed and blend that with the strobes. **Next I put a grid spot low on the ground in front of the racquet and one high to the side of Michael Chang's face, and – voilá. It's just in focus enough to make him recognizable.**

In order to control the light on the subject, and still be able to mix artificial light with the available light to illuminate the background, I used a 6 x 6 black panel above the subject to block the light.

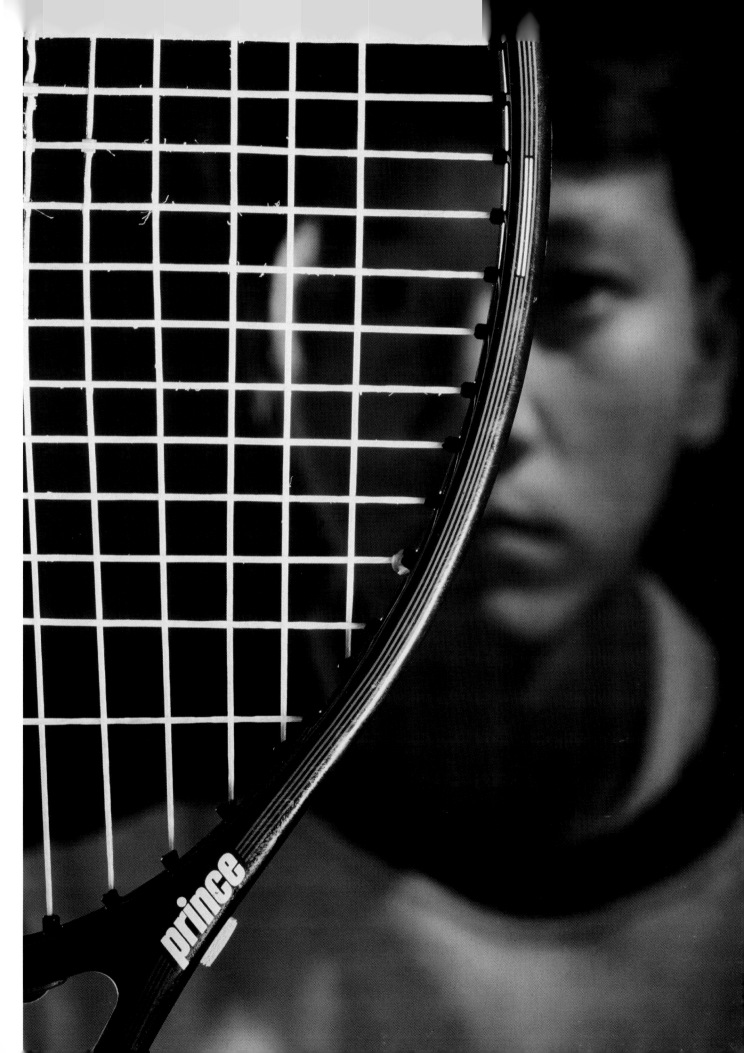

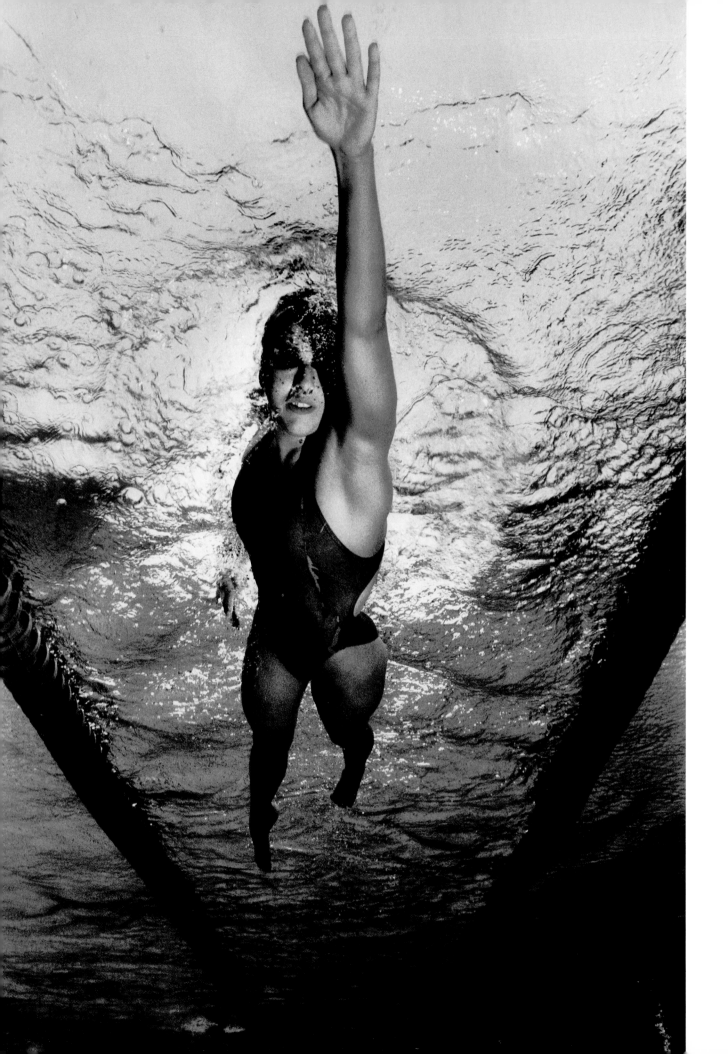

This was shot for a special issue of Newsweek to spotlight a group of highly accomplished athletes before the Summer Olympics. I shot multiple Gold Medal winner Janet Evans above the water first, in a dramatically lit but fairly straight-forward portrait of her holding onto the floats that separate the lanes. **Since I dive, I had also rented scuba gear and an underwater camera, and told the photo editor I wanted to shoot her swimming.** I shot one color roll of her swimming, but she was in the middle of training and needed to leave at that point.

I begged her to let me do one more roll, since I had brought a roll of black and white infrared film to try. Because of the time situation we had to load the one underwater camera outside, in the heat, in a changing bag. This is not a trick Kodak suggests you try. **Infrared film should be loaded in a dark room in a changing bag – and for good reason.** As a result of the imperfect loading conditions, this was the only frame out of the half roll she let us shoot that was not fogged. Another in the long line of happy accidents!

Because the pool was so deep, I used the extra height of a C-stand arm on a light stand and placed an underwater strobe on top of that at the bottom of the pool with a sand bag anchoring it. This got the light close enough to Janet, who was swimming on the surface, to be powerful enough to match the exposure of the sky through the water. **I next threw my weight belt to the bottom of the pool and tied myself to it so that I was at the right height every time she swam by.** This helped insure the half roll of infrared photos were all at least shot from the right distance and lit consistently.

This was the only frame that came out on the black and white infrared film. I was under the water using an underwater flash and made one shot each time she swam by.

SWIMMER

UNDER WATER FLASH ON A LIGHT STAND ON THE BOTTOM

NIKONOS RS UNDER WATER CAMERA POINTING UP FROM THE BOTTOM

JECT:	Janet Evans
IENT:	Newsweek
TION:	U.S.C., Los Angeles, CA
OTES:	B & W Infrared Film Underwater

Shadow Boxing

This image was shot as part of an exercise story for Men's Health magazine. The story was called "Lean for Life" – and if I stuck to the workout as well as I shot the story I'd be 20 lbs. lighter. Anyway, I had to shoot a series of very specific exercises on various machines. We went though all the parts of the body from legs, to running shots, to upper arms. We also shot an illustrative photograph with a tape measure around the model's waist.

I needed one more shot of him shadow boxing to complete the day and, being me, **I wanted to make a very dramatic "big" shot out of it.** Since the art director for Men's Health, Kay Douglas, was there we decided that if the shot worked it could run across two pages. One of the walls in the studio just happened to be that weird "pyro" brick and we decided to use it for maximum interest in the shot.

The lighting is relatively simple: one Dyna Lite strobe head on the left side placed down low with a very wide grid, and a head from the right side with a 20° grid spot placed at about shoulder height. **The light on the left side makes the shadow up the wall; the light on the right illuminates his muscular back, which was also a part of the story.**

After shooting all day in this studio I noticed the interesting brick on a corner wall and came up with this shot.

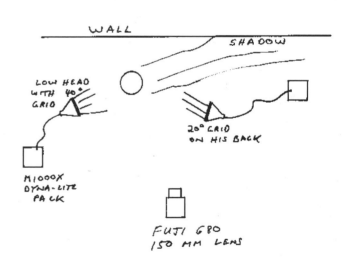

SUBJECT:	Lean for Life
CLIENT:	Men's Health
LOCATION:	New York, NY
NOTES:	Two Lights

Finding the Angle

This boxer was part of a boxing work-out story shot for Men's Fitness. It's not a traditional portrait, but has interesting potential as part of a story or spread on someone in a magazine, so I've included it. We found a real boxer to use as a model for the story. In this case though, who he was was not important, so I never shot a portrait of him.

After shooting the subject jumping rope, punching a heavy bag, and taping his hands, I needed to shoot him using a speed bag. The speed bag is a typical shot, but I needed to do it, so I wanted to make it different. **I picked the low angle in order to use the circular backboard as a graphic element for the shot.**

As we tried to set up the light I had trouble eliminating the reflection off the sides of the shiny surface while retaining light from the angle I wanted. But as I always say, if you can't beat 'em, join 'em. So, instead of trying to get rid of the reflection, I used it as an element in the picture. **I always like to challenge and break the rules rather than following them blindly.**

To help show the shape of the backboard, I lit the ceiling so that the outline of the circle stood out more.

Because I had trouble getting rid of it, I used the reflection off the backboard to make the shot different and more graphic.

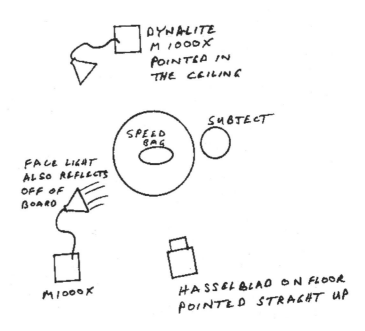

SUBJECT: Boxer

CLIENT: Men's Fitness

LOCATION: Los Angeles, CA

NOTES: Shot from Floor

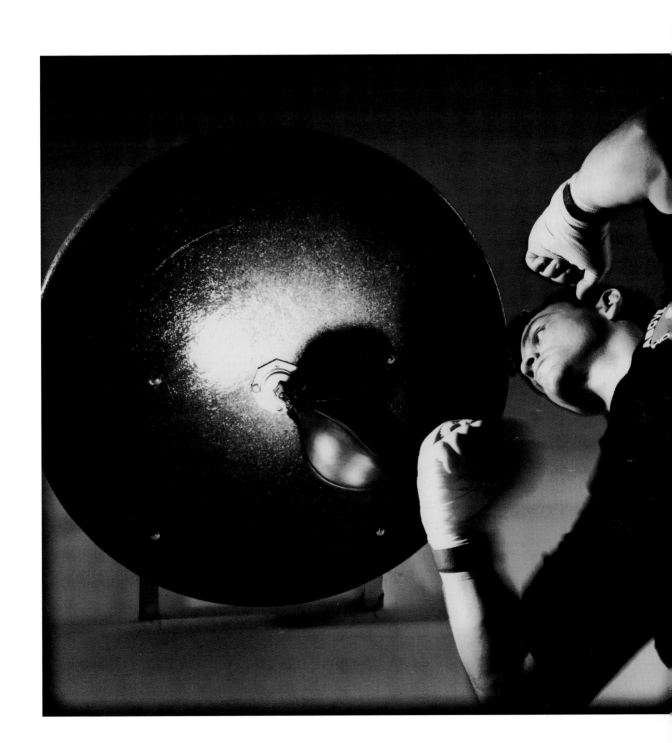

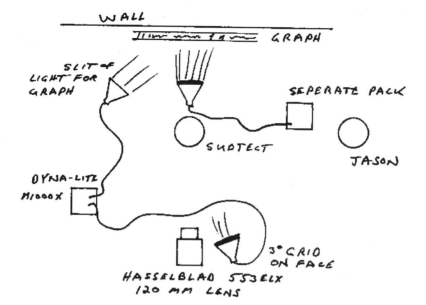

I was commissioned to photograph the W. M. Keck Foundation's Annual Report. The foundation gives grants for education and research, so the portraits were split between students (the final recipients of the grants) and the professors or researchers (the more immediate recipients of the money). **This man was a seismologist, researching volcanoes and earthquakes around the world.** He was on Reunion Island most of the time we were shooting the annual, and the client toyed with the idea of flying us to Madagascar (off the East Coast of Africa) and then flying to Reunion Island. But the cost in time and money was too great.

Instead, when we were almost finished with the report, he came back to his office at the University of Southern California which allowed us to shoot him there. This meant I was left with trying to figure out how to switch gears from shooting the subject at a volcano half way around the world to shooting him in his office. **I decided to play with the earthquake idea visually.**

To do that we took one of his seismological graphs and taped it to the wall behind him. Next we "blacked out" the room so that we could make multiple exposures with the shutter open and not have the room light interfere. Then I lit Dr. Aki's face with a tight 3° grid spot strobe. To light the graph I used a slit of light that I made using barn doors on a strobe head. These two Dyna Lite heads were plugged into one pack and then plugged into the camera. Next on a separate pack I put a 10° grid in the back wall, not "synched up" to the pack or the camera. As I shot, I left the shutter open and panned the camera from left to right. In each position of the pan my assistant, Jason Hill, would fire the head aimed at the wall. This made multiple exposures of the background only and gives the earthquake effect without messing up his face. I had to be very careful not to move the camera too much and cause the background to bleed in to his face.

Visual Metaphor

To get the earthquake concept across, I fired a separate strobe head on the wall as I moved the camera with the shutter open.

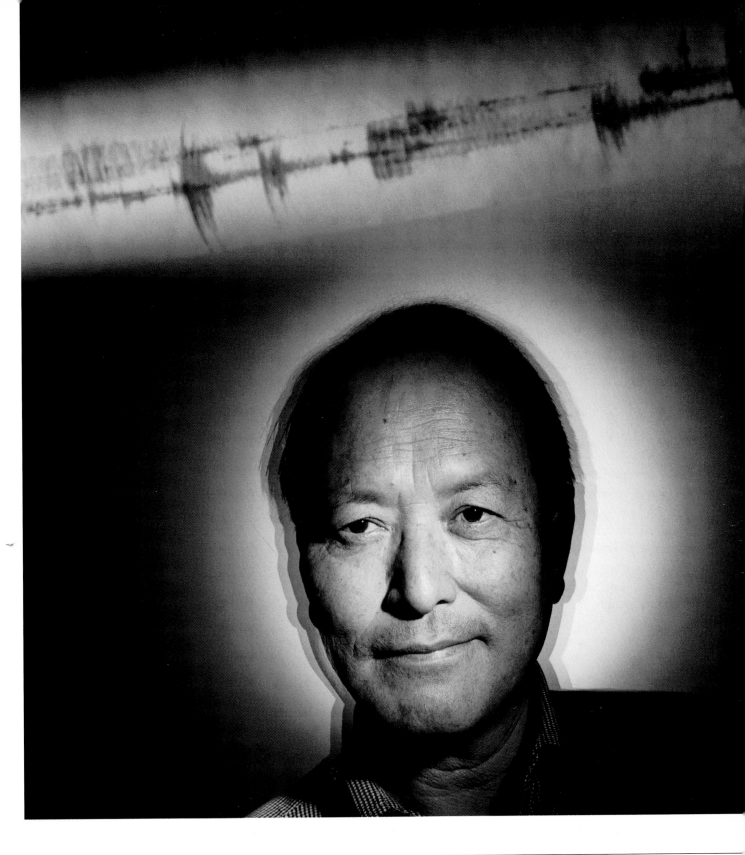

SUBJECT:	Dr. Aki
CLIENT:	W. M. Keck Foundation
LOCATION:	Los Angeles, CA
NOTES:	Multiple "pops" on the wall

SUBJECT:	Michael Heim
CLIENT:	Profile
LOCATION:	Los Angeles, CA
NOTES:	In Camera Multiple Exposures

Multiple Images In-Camera

For this portrait of Michael Heim, a writer on the state of virtual reality and a Tai Chi master, I wanted to combine both aspects of the subject into one photograph. The article I had to illustrate was written by him and centered around how he did not want to see virtual reality used solely for entertainment, but also to explore the inner self. This was a subject I was fascinated with and an image immediately popped into mind. **Because of his interest in Tai Chi, I saw him as Shiva (Nataraja), the Hindu dancing god with many arms.**

I started by blacking out the windows in the room so I could pop the strobe multiple times during the long exposure. Next I set up the Fresnel light to illuminate his face and hands in the first of three hand positions. The Fresnel light was on its own pack synched to the camera. We planned it so that when the subject "hit" the second and third positions with his hands, the assistant would fire the pack attached to two 3° gridded strobe heads to light those gestures. **This would all be done during one open exposure of the camera.** The problem was, the room was very small and the light bounced around so much that his face became transparent from the second and third "pops" of the flash. To fix this, after the first exposure, I dropped a little piece of tape over the lens in the shape of his face. This blocked any additional light on that part of the film. The hard part was finding his hands in a near black room and then all of us getting blasted by the strobe light.

To add more interest to some of the shots, I also rocked the lens to throw his hands out of focus in some of the gestures. This is a trick I learned from my college photojournalism teacher, Ken Kobre, when shooting fireworks next to him. **I took a long time to shoot very little film, but I think it was worth it!**

For this shot I wanted the subject, a Tai Chi master and virtual reality specialist, to look like the Indian god Shiva with all his hands.

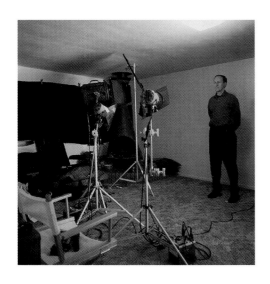

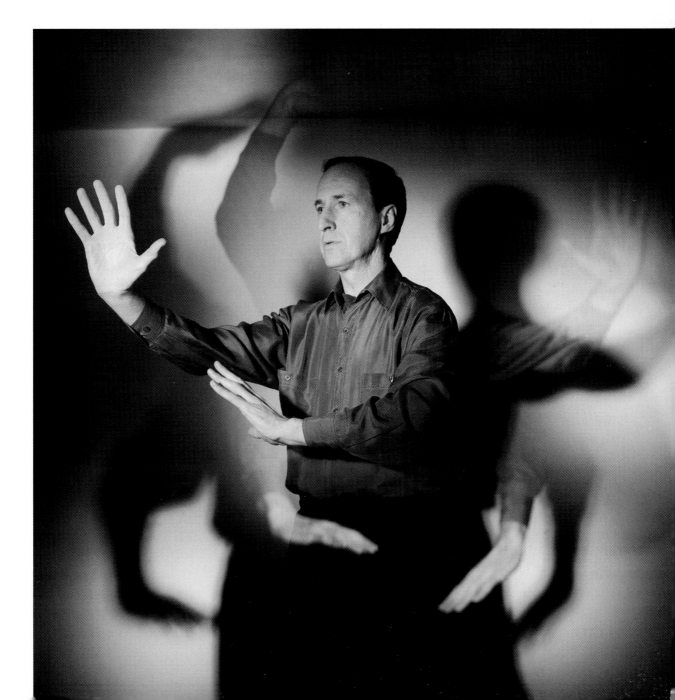

SUBJECT:	Dave Whitley
CLIENT:	Discover Magazine
LOCATION:	Mojave Desert, CA
NOTES:	Multiple Images in Computer

HIGH CONTRAST CLOSE UP OF THE PETROGLYPHS

PORTRAIT- SHOT LATER

MOUNTAIN- SHOT ON THE WAY THERE

CLOUDS - SHOT ON A DRIVING BREAK

Because of the high winds in the desert during the shoot, I could not set up a backdrop to do all the multiple exposures in camera. Instead, I decided to shoot all the pieces separately and have them put together in the computer.

Using Computers

I was assigned by Discover magazine to photograph an archeologist who discovered that Indians had made petroglyphs during vision quests. The Indians would fast, get high on tobacco and carve their vision into the stone.

When I went out to the desert for the shoot, I thought I would double-expose the rock drawings and the subject's face in camera. I planned to experiment on the spot and come up with something cool. To do the double exposures, I wanted to shoot the subject against a black background, but it was so windy in the desert that I could not set one up.

As a result, this became my first photo composition done on a computer. While at the rocks I shot the drawings in many ways from different angles. Then I found a house with a big porch to shield us from the wind. We set up a black background and shot the subject a number of different ways. On the way to the Mojave, I had stopped and taken some shots of cloud formations I liked. When I came back to my studio I looked at all the contact sheets and played with some possible compositions. **When I finished I gave them to my Photoshop retoucher with lots of directions and she made the magic you see here. I still like the analog feel of doing things in camera, but this certainly solved a problem in a difficult situation.**

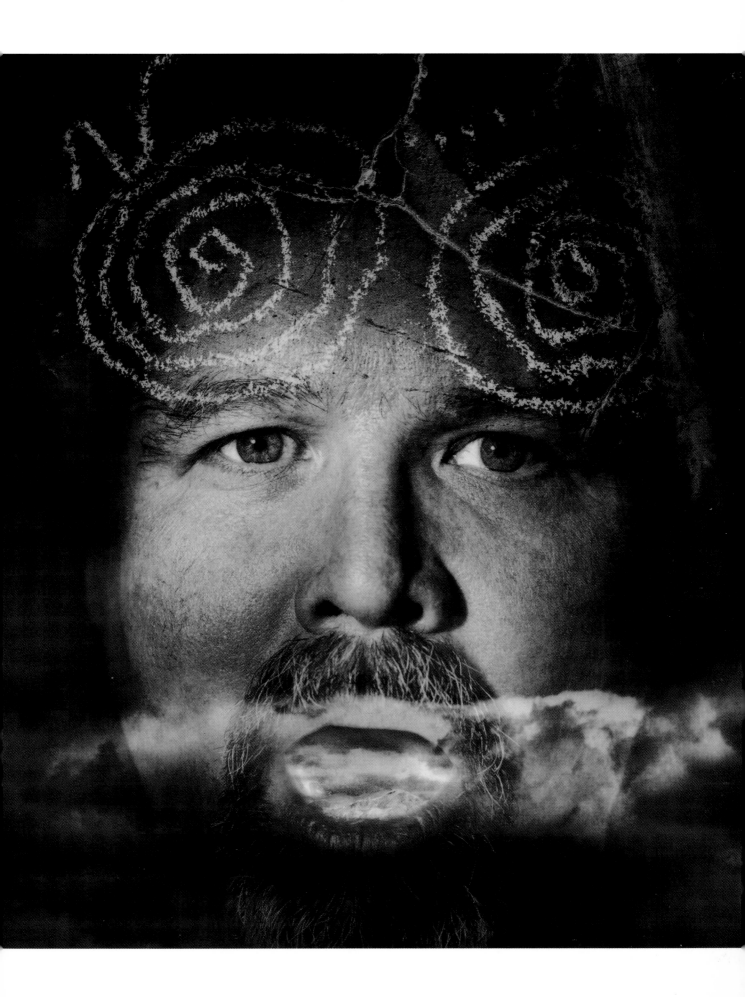

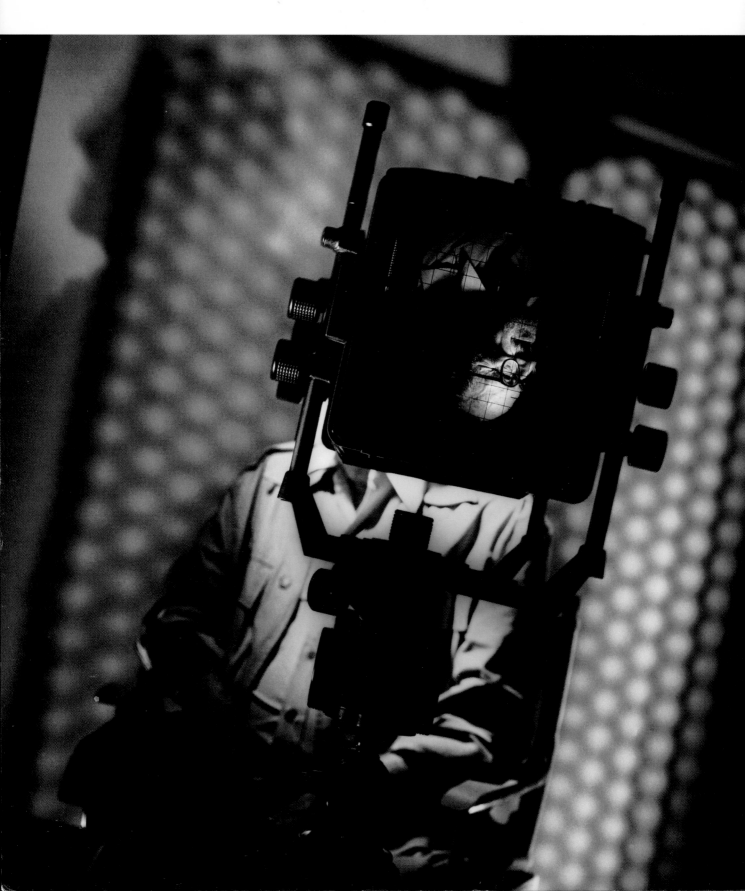

Capturing A Legend

The first year I taught at the Santa Fe Photographic Workshops, I had the honor of teaching across the hall from one of my childhood heroes, Arnold Newman. For the first demonstration of the week I had requested, through the regular workshop channels, that Arnold sit for me and I heard that he did not want to. So when it came time to do the demonstration and I had no one to sit, I went across the hall and grabbed him, sort of kicking and screaming, but not fully. He had no idea of what I wanted to do even as he sat. It wasn't until he saw a print afterwards and went "wow" that I knew he got it.

The concept is simple: "reflect" a photographer though through a camera, since all I really know about him is his photography. What I like about it is the upside-down head and the shadow profile on the wall. Because I had to improvise, I used a projection screen for a backdrop. Then we set up one of the class 4x5 cameras so it would replace the sitter's head with the inverted image of the ground glass.

Next I set up two hot lights on the right side of the frame, one to give the profile shadow and the other through one of my metal pieces from the "X-Files" set to create the hole texture. Once I had a Polaroid that established the look, I added a strobe head with a 10° grid light where Arnold would be. Because you lose so much light through the camera until it hits the ground glass, the strobe for his face had to be three or four stops brighter than the shooting exposure. The fun part was keeping two cameras in focus at the same time.

It was truly one of my favorite experiences though, to photograph one of the world's best portrait photographers — and get to show him my work later that day. I will never forget it.

To get Arnold's image to be seen through the rear of the 4x5 view camera I had to over-light his face about four stops so that the exposure on the glass would be the same as the rest of the shot.

SUBJECT:	Arnold Newman
CLIENT:	Self
LOCATION:	Santa Fe, NM
NOTES:	View Through a 4x5

"To tell is to know, to listen is to learn."

I want to use this picture of Martin Landau to talk about another piece of the portraiture puzzle. Whether it is a painting or a photograph, great portraits are far from technique, composition, or concept alone. They are made by the engagement of the viewer with the image. That is accomplished by the interaction between the photographer and the subject. **The relationship caught on film brings life to all the lighting, props and concepts – a synergy.** Without it, an image might be a technical success, but never engage the viewer in any way – unless the viewer is a photographer awed by the technique alone. Our peers should not be our sole audience. Great photographs and works of art have the ability to change people's perceptions and attitudes, to inspire, and to change peoples lives. We as an industry, group, or society of photographers should never "shoot" for less.

So many young photographers, amateurs, and "weekend" photographers get caught up in the gear. As I mentioned earlier, don't worship it. Kick it around every once and while, and realize it's only a tool. I have talked a lot so far about how I've achieved my images in a very technical way; the truth is that I have had to think hard to reconstruct the techniques for this book. **I try to light and create my concepts from instinct and intuition. I squint a lot and to try and picture what I want to achieve and always feel the mood of my image from my heart.** That is the basis for the techniques I use, and also what I try to do everyday in connecting with my subject. Come from a place in the heart. The subject is the first to know if you are insincere with them.

I understand the "technophile" because I have been there. I work on my ability to get to the soul of my subject every day – to go beyond the technical to achieve a more revealing photograph. It's not always easy, but to me there is no other way, and no turning back. Once you have seen how compelling that engagement can be, there is no going backward to a portrait that is strictly based on technique.

This connection I speak of should be made with everyone from an Academy Award winning actor to a five-year-old. **You must find the common ground, whether that means you are on your knees, eye to eye, talking to the child, or discussing the actor's latest movie (which you took the time to see the night before the shoot).** The same research I do to figure out what the concept of the shoot is going to be, I also use to know how to relate to the subject. I get press kits, listen to their records, read some of their work, go see their movies, look at their head-shots, and pick up magazine articles. Whatever I can do in the time allotted, I try to do. This research gives me the information I need to have an intelligent and sincere conversation with whomever it is I am photographing.

I do have the advantage of having done this for many years, and I draw on my life experience in every situation. If I am shooting an actor or actress I will also sit with him or her before the shoot, in hair and make-up, and chat for a while, in between directing my crew in the set-up of lights and equipment. I will strike up a conversation about make-up, clothing designers, a director, movies, shoots I have done, and listen to what the subject is interested in. That sets the tone for the entire shoot and turns their focus away from the camera, and onto enjoying conversation and relaxing. **Always lead from the heart and be sincerely curious – most people feel comfortable and enjoy talking about themselves. I got a great fortune cookie once that said: "To tell is to know, to listen is to learn."**

The relationship you have established with your "talent" will be conveyed when you are ready to shoot. A good relationship will make you more likely to get the proper eye contact, or capture a perfect moment that arises from that connection. The synergy between your technical and creative knowledge, and the expression you have captured will be amazing. **As you can see in the Martin Landau portrait, the drama of the lighting and the environment is not nearly as important as the drama of Martin Landau.**

"The Moment" is what makes this picture so strong. It is a synergy between photographer and subject.

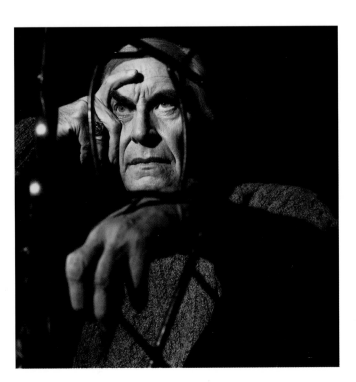

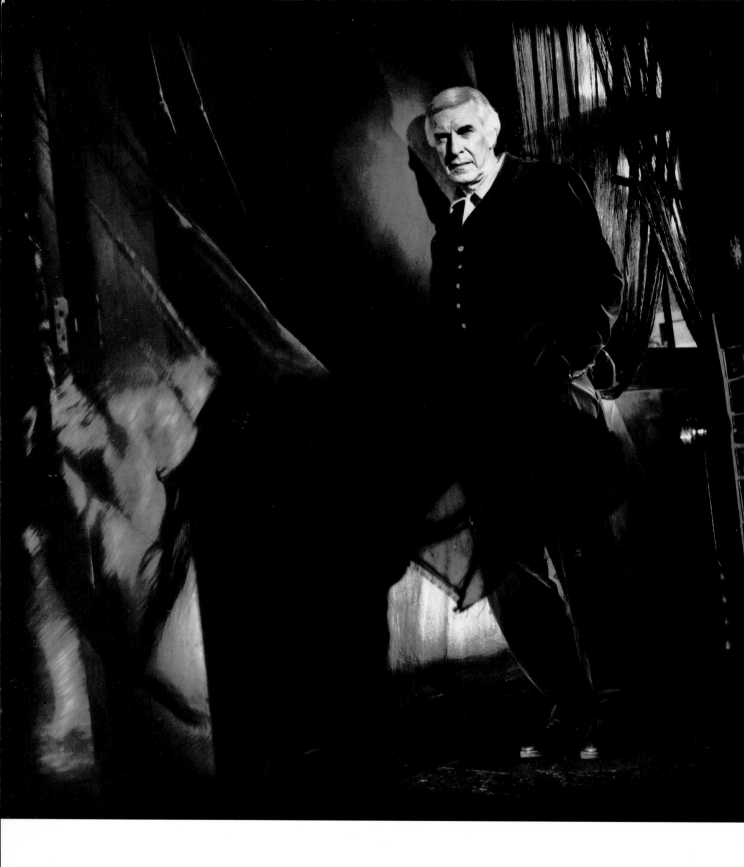

Location as Concept

I was given an assignment to photograph Martin Landau for Entertainment Weekly after the movie "Ed Wood" came out. I was in New York on a shoot and the photo editor, Doris Braugtigan, asked me if I could fly back to L.A. and do the shoot. I agreed and, before I left, went to see a press screening of the movie. The film was an eclectic story of the director Ed Wood's life and his relationship to Bela Lugosi who played Dracula in the movies of the thirties. The hype was that Landau was going to get nominated for an Academy Award for his performance. I was blown away by Martin's acting in "Ed Wood" and **when the movie was over I immediately knew how I was going to shoot him.**

In Hollywood, there is a great Baroque looking restaurant called Café La Boheme. It has a great mix of up-scale style, and a dark "Dracula-esque" mood I needed for this shoot. A perfect combination, **the location alone would be the concept for the shoot.** This shot was the first of three or four I had to make quickly that day, because we only had the actor for a few hours (and that included the time needed for hair and make-up). **I needed two shots for the feature story the following week, a picture for the year-end issue, and as always I wanted to shoot an extra image for the table of contents spread.** The shoot was also restricted by the need to shoot between the lunch and dinner crowds at the restaurant.

In the entrance of the restaurant there was a great metallic curtain and painted walls. I untied the curtain and let it blow into the shot. To get the wind working with us an assistant opened the front door a crack to let the air flow through. Next, I put a hot light in the doorway out of the shot to light the curtain. **Because the hot light is a continuous light source it would allow the curtain to show some blur or movement in it.** Next, I placed a light to the subject's side – almost like a back light that both created the shadow of him on the wall and opened up the very dark suit he was wearing. The last light was a grid spot to open up his face and make the exposure for the scene go up so that I could close the f/stop down and make the overall picture darker and more dramatic.

When I was assigned this story, I went to see a screening of the movie "Ed Wood." After seeing the film, I knew this location, Café La Boheme, would have the right feel for the shoot.

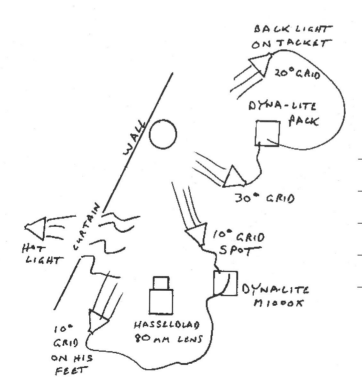

SUBJECT:	Martin Landau
CLIENT:	Entertainment Weekly
LOCATION:	Los Angeles, CA
NOTES:	On Location in Cafe

This image has become a signature image of mine and is being used in a Hasselblad ad campaign called "Hot Shots." There is a great story behind this image, the last one from the shoot.

I loved the staircase railing in the restaurant; it had a beautiful wrought iron weave pattern. I set up this shot for color and lit it with three lights. The first light was my custom Fresnel at the bottom of the stairs on Mr. Landau's face. A small grid spot on a Dyna-Lite strobe head was focused on the wall to separate him from the background. The last light, a very tight grid under the railing, was there to separate the railing from the subject. I had done two shots in black and white and this would be my second shot in color. I chose color because of the deep, burgundy red wall in the background. As a back up, though, I mixed in some black and white in this situation also. We were just shooting feverishly to get it all done and packed up before the restaurant opened for dinner.

The next day, when I looked at a test frame to determine how to process the film it looked great. The exposure was right on the money. But later that day when all the color film came back, none of it matched the test. Someone had blocked the optical slave on the second pack (which controlled the background light and the railing light) and neither assistant noticed it. I was fit to be tied, cursing and mumbling at them and to myself. I did not know what to do.

The next day the black and white contact sheets arrived at the studio and my emotional state went from frustration on the day before, to joy. Not only did the shot work better in black and white, it also worked better with fewer lights. Then to top it off, Mr. Landau had hit his character and the mood for the shoot superbly. The emotion and pathos in his face helps make this shot great. It is the perfect synergy between concept, lighting, and his soul. Another happy accident – this time achieved by covering the situation with multiple types of film.

In this shot two of the three lights I set-up did not fire, making the color unusable, but adding so much to the black and white.

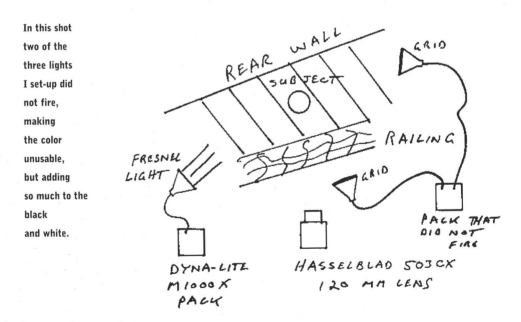

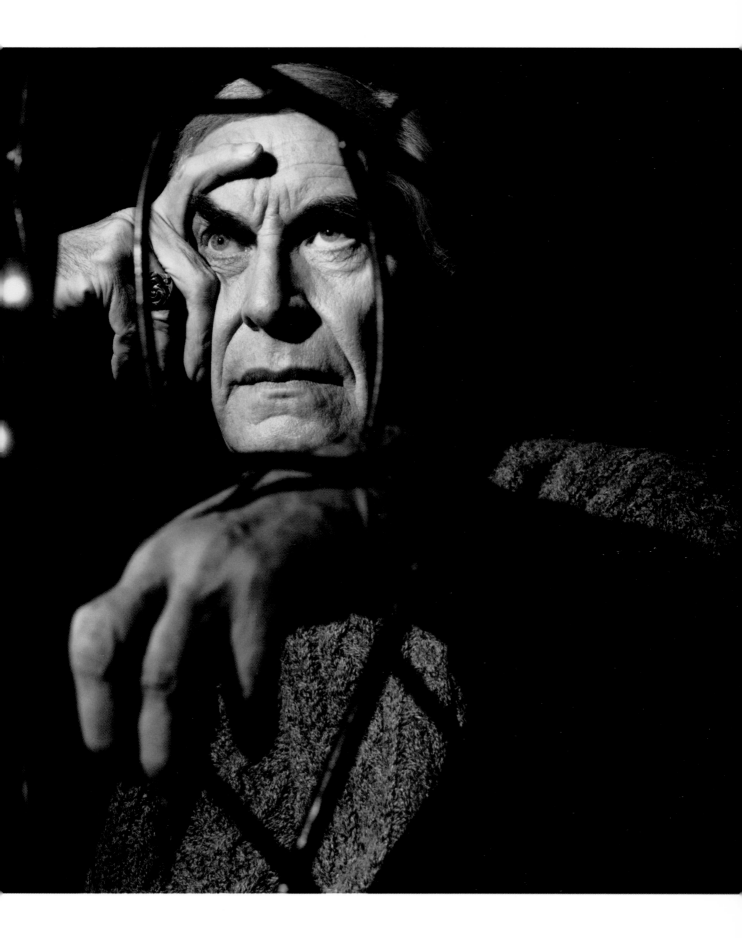

This was an assignment from Jack Lemmon himself through his publicist. He needed a head shot for a charity event and I was asked if I could go to his office and shoot some publicity photos of him. Before the shoot I was trying to figure out what I could do for my portfolio or to further my career. I had just left photojournalism and was working on building a nice portfolio.

This falls under the category of "letting go of the outcome," because sometimes the results you get are better than what you expected. I had been toying with the idea of creating a series on people's hands and when the shoot was over I asked Mr. Lemmon if he would do some hand shots for me.

He is a most amazing actor and persona – I was in awe of the drama he brought to the shoot without saying a word or needing any instruction. What he did with his hands on his face was amazing. The only thing I could do was to just keep on shooting – he really did the rest, and I just captured it on film. In this way, **the shoot became a great synergy of a preconceived idea and a great performance by Jack Lemmon.**

To light the portrait I used a single soft box. This simple lighting gave me the most freedom to move around with him, and was extremely flattering.

To keep this shot simple and flattering I used one softbox to light his face. This enabled me to focus on his expressions and not have to fiddle around with the lights.

SUBJECT:	Jack Lemmon
CLIENT:	Publicity Photograph
LOCATION:	Los Angeles, CA
NOTES:	One Softbox

Robert Evans once ran one of the biggest studios in Hollywood and had some highs and lows, as we all have, in his life. I was assigned to do a large feature on him because of a book he had written. Before getting there, my idea for the shoot was to have him partially submerged under water, to sort of symbolize life's ups and downs. Unfortunately, he had recently been photographed with his unclad girl friend and the picture had created a minor scandal. Because of this he was not willing to take off his shirt or go in the pool. He has a window above the fireplace of his living room that looks out to the backyard, so I started by shooting him through the window from the inside looking out at him. **I was very disappointed that my first idea for using the pool was turned down but, as I try to do, I kept my eyes and mind open.** As I was shooting I noticed that one of my strobe heads was making these great shadows in a small vestibule where there was a sculpture. So we moved the sculpture and made our next shot in that vestibule. I added just one more 3° grid spot to the upper right area to fill it in and balance the light and dark areas of the photograph. When Robert hit that great pose I knew I had the shot I needed. It ran as a two page spread to open the article.

This picture was lit by shadowy light from a chandelier in another room. A 3° grid spot was used to fill in the dark shadow from the doorway and balance the light and dark areas.

Improvising

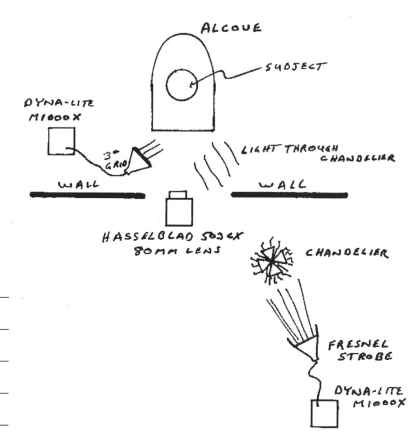

SUBJECT:	Robert Evans
CLIENT:	Entertainment Weekly
LOCATION:	Los Angeles, CA
NOTES:	Lit by Chandelier

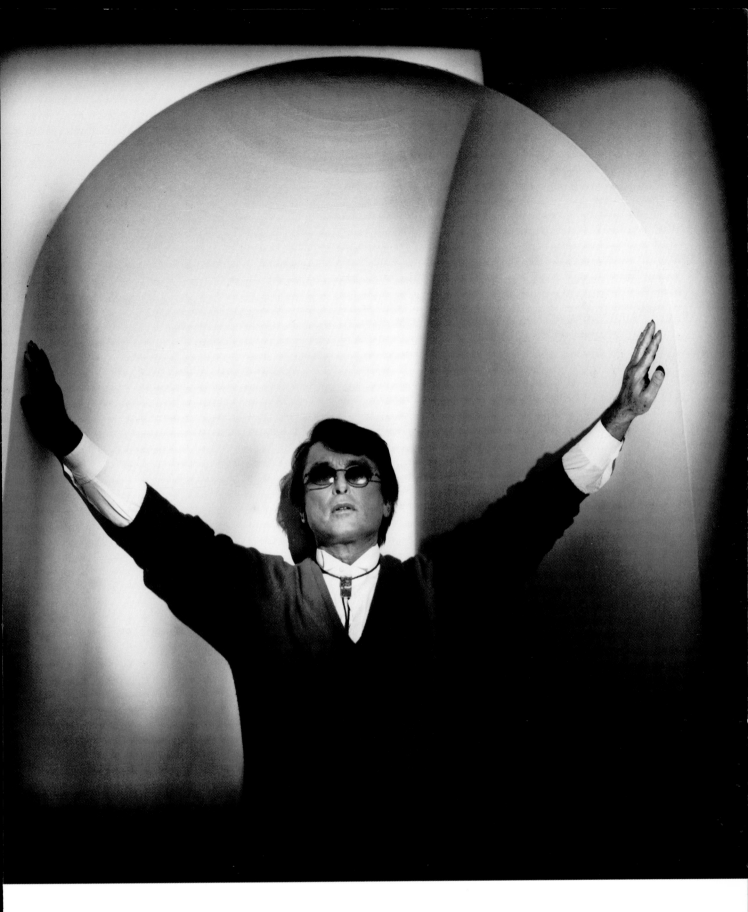

I shot Quentin Tarantino for "20 Questions" article for Playboy. We did a couple of situations that day, one of which was a shot with his favorite food, Captain Crunch.

This shot came to me by chance. **I did not want to duplicate a lot of photographs I had seen of him with guns, dead bodies, or blood.** As I was walking down Main Street in Santa Monica, I saw this great prop in the window of a store. It was a Frankenstein-esque voltage generator. Since he had written and directed both "Reservoir Dogs" and "Pulp Fiction," **I made the loose association of him as the "high voltage" director.**

The great thing was as we started doing the shoot **he really played with the prop and helped the shot work.** Because the other set-up required shooting at this location, we also shot this image in the back of the Hollywood Canteen, where they have an old Airstream Trailer in the back. I used just one light, my Fresnel strobe, with the light partially blocked off by barn doors. Then I blended the available light to fill in the shadows by increasing the exposure time.

I used this prop to create the concept of Quentin Tarantino as the "high voltage" director. It also works on other levels, playing off of the campy side to his tastes and personality.

SUBJECT:	Quentin Tarantino
CLIENT:	Playboy
LOCATION:	Los Angeles, CA
NOTES:	Voltage Generator

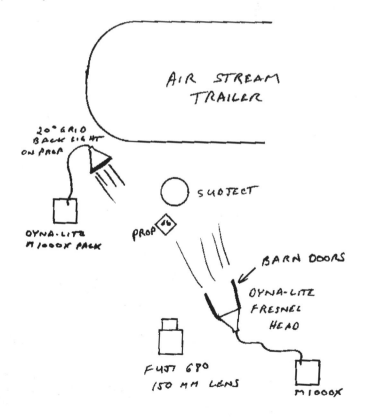

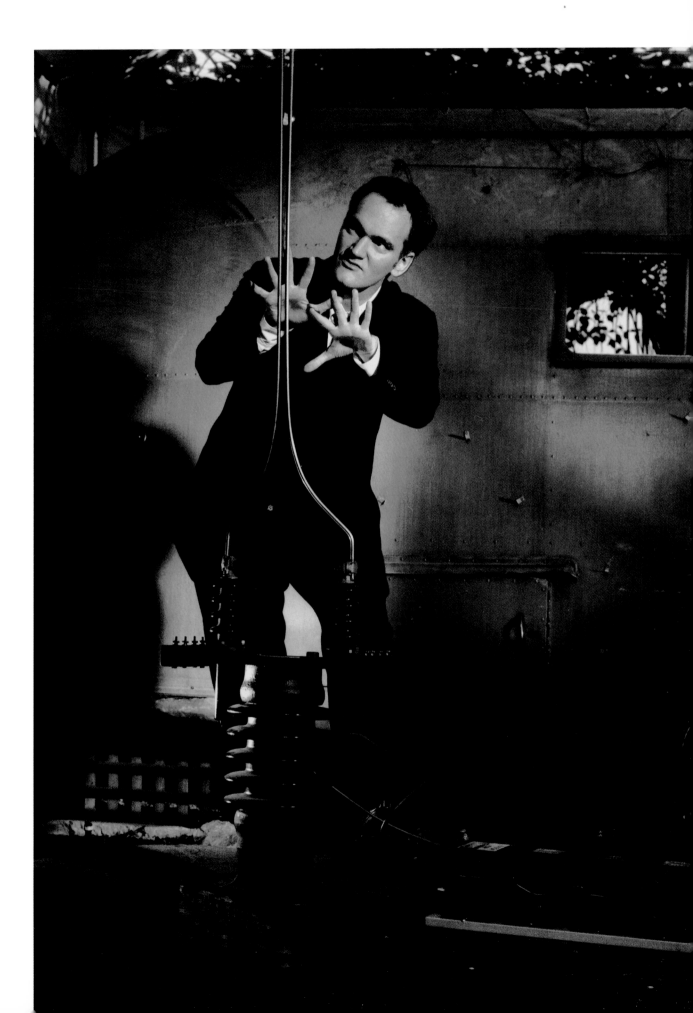

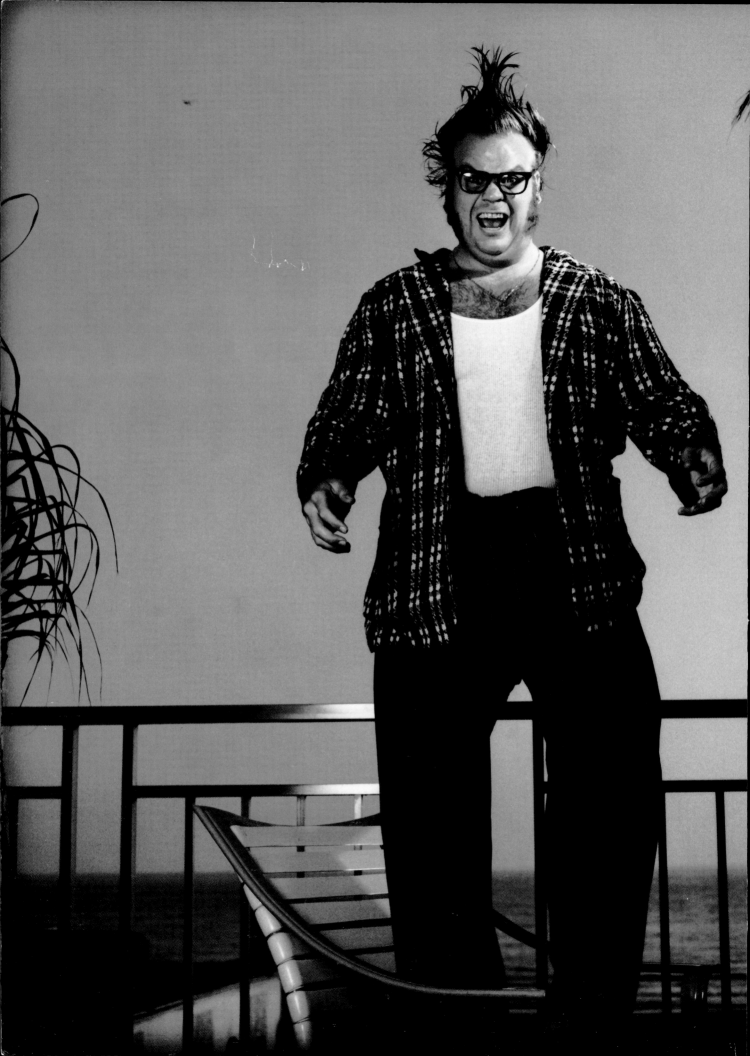

Capturing Genius

This was a cover of the one year anniversary issue of Bikini Magazine. I was asked to shoot Chris Farley at a beach hotel near my house in Santa Monica. He was several hours late because his plane from Toronto had mechanical difficulties. I used the extra time to set up equipment, load cameras, and go over the clothes and props the stylist brought. When Chris arrived he was so exhausted I thought the shoot was a goner. If he had no energy to put out, these shots would be lifeless.

I went over a couple of the ideas with him and as we started shooting he just came alive. **He was able to go beyond his exhaustion and be 100% there for the shoot.** He was amazing! We put him in mismatched pajamas and he said "How about me having my hair stick up?" – which made for this wild shot.

He was an animal – in the best possible sense – with an amazing energy that I tried to capture on film. He had lots of ideas. I could give him the visual seed of an idea by dressing him up in a silly outfit, and he could carry the rest of it off to a level of utter outrageousness. **It's hard for me to look at this shot now, because it was one of my favorite shoots and also, since his death, my saddest to look at.** He was truly a comic genius.

Chris Farley's energy was amazing. After being delayed on a flight all day from the east coast he arrived in L.A. and performed amazingly for this shoot.

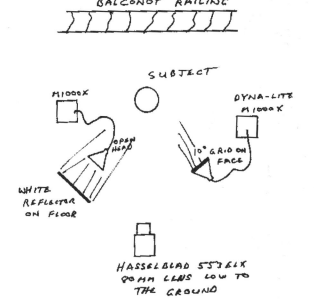

SUBJECT:	Chris Farley
CLIENT:	Bikini Magazine
LOCATION:	Los Angeles, CA
NOTES:	Available Light

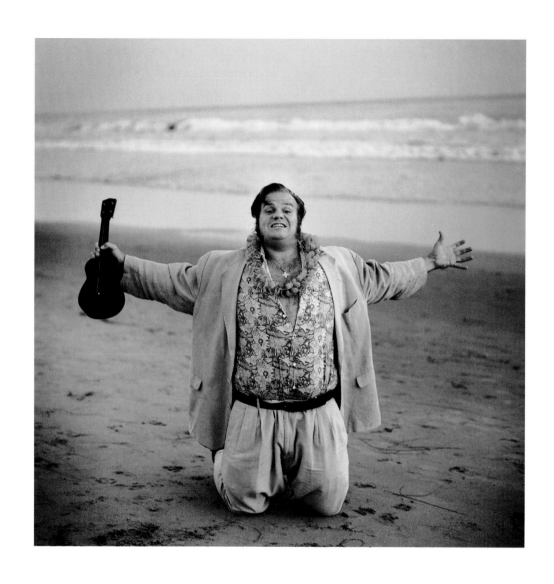

With a
little bit of
wacky
clothing and
after throwing
around
some ideas,
Chris Farley
became
the "super
nerd."

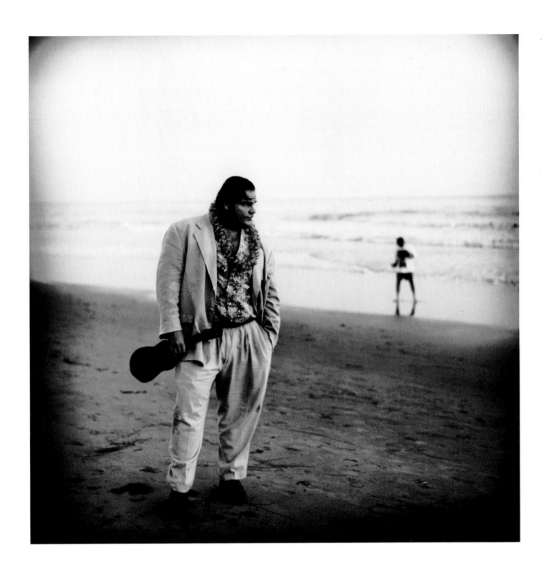

After we shot Mr. Farley in and around the hotel, I took him down the block to the beach. The indoor shots needed to be lit, but after seeing his incredible energy I wanted to just let him loose on the beach. The light was soft and low so I decided to shoot using only available light. **Remember never to let the technical details or the light stop you from capturing the emotion of the moment.**

Before we left the hotel I had the stylist, Xavier Cabrera, outfit Mr Farley in a white suit with a lei and a ukulele. He looked like a wacky member of the Beach Boys. He started playing to the camera, and I was able to just run with him, so to speak. I also vignetted the lens to create the effect of a "tunnel" perspective.

The comedian's range was amazing; he was high energy at the beginning on the beach, and then somber and poignant towards the end of the shoot. I have included both shots. The quietly reflective shot ominously tells the other side of a possibly troubled and tragic end to an incredible artist. Here is a perfect of example where a shot is not about the light or the technique, but about the subject's engagement and emotion.

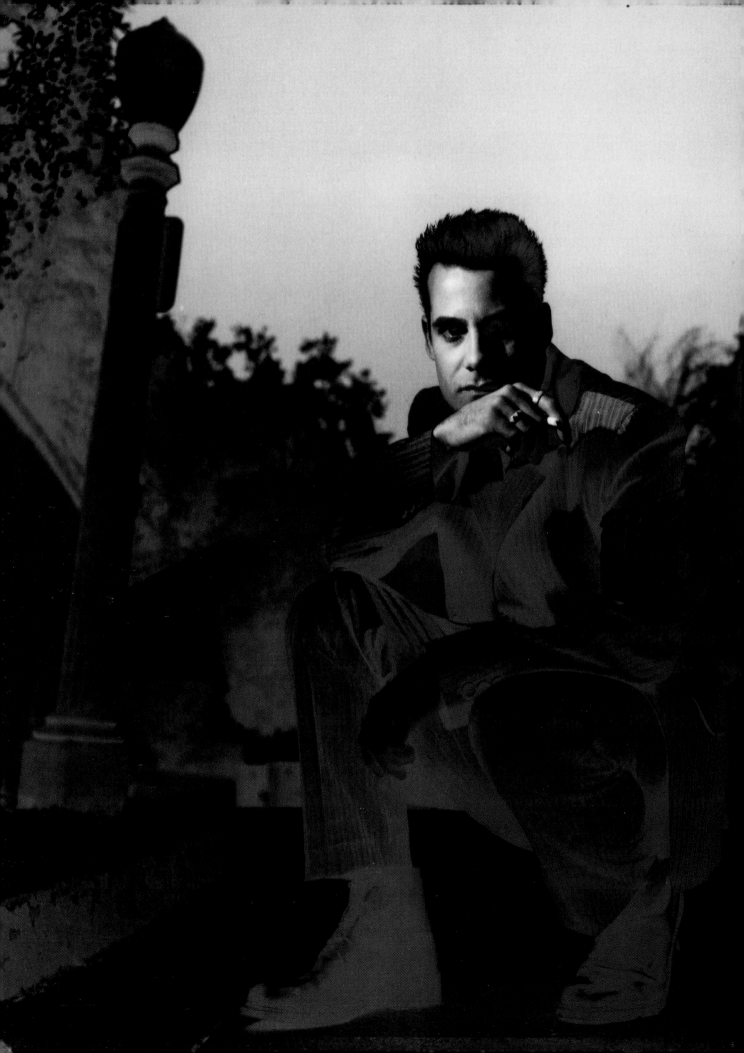

SUBJECT: Adrian Pasdar

CLIENT: Entertainment Weekly

LOCATION: Los Angeles, CA

NOTES: Solarized Polariod

Solarized Polaroids

These **portraits of actor Adrian Pasdar** were shot for Entertainment Weekly. The story was about a new show Fox was doing, called "Profit for Hire." The show did not last long, but the pilot was great! It was very dark, with Adrian's character exterminating people in order to move up the corporate ladder.

For the shoot (left) we rented a bungalow at the Chateau Marmont in Hollywood to do the actor's wardrobe, make-up and hair (for male subjects, hair & make-up is called grooming). Then we shot on the street outside. The street was very quiet, so I could pose him in the middle of the street and be fairly safe. I pulled power from the bungalow and I lit the subject with a 10° grid on a Dyna Lite head. The image was shot on Polaroid 665 with my Fuji GX 680 Camera. **Then I solarized the negative by holding the negative under a hot light after it had developed for only fifteen seconds.** The development time for this technique varies with the temperature. I wanted only his body to be solarized. Because only the dark areas of an image which solarize, I did not light his body, but only his face. This created dark areas on his body which solarized to negative, and left his face unchanged. This shot ran inside the magazine with the body of the story.

To keep the very moody feel of the TV show that he was in, I chose to shoot solarized Polaroid negatives and light them very dramatically.

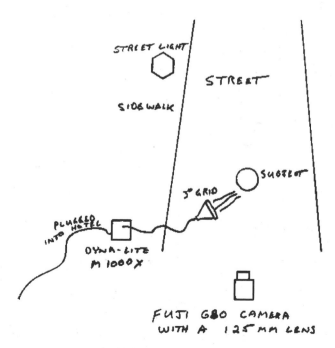

STREET LIGHT

STREET

SIDE WALK

SUBJECT

5° GRID

PLUGGED INTO HOTEL

DYNA-LITE M 1000X

FUJI 680 CAMERA WITH A 125 MM LENS

I did this tight shot (opposite page) for the table of contents spread in the magazine. The actor's eye is lit with an LTM 620 watt "pepper" light (a hot light). I used this light instead of a strobe because I have a little optical spot attachment for it which could make that very small circle on his eye. Then I added a strobe as a back light to separate him from the dark night background. The street light provides the rest of the ambiance in the shot. **To capture it on film I left the shutter open for a long series of exposures. The exposures ranged from 1/8 second to 2 seconds as it got darker outside.** To create the final look, this image was also solarized. It ran as a two page spread in the table of contents.

An optical spot on a hot light was used to create a circle of light on the model's face. Although it was hard to balance the hot light with the rapidly changing sun setting in the background, the effect worked well.

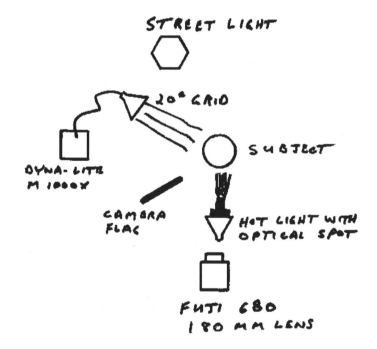

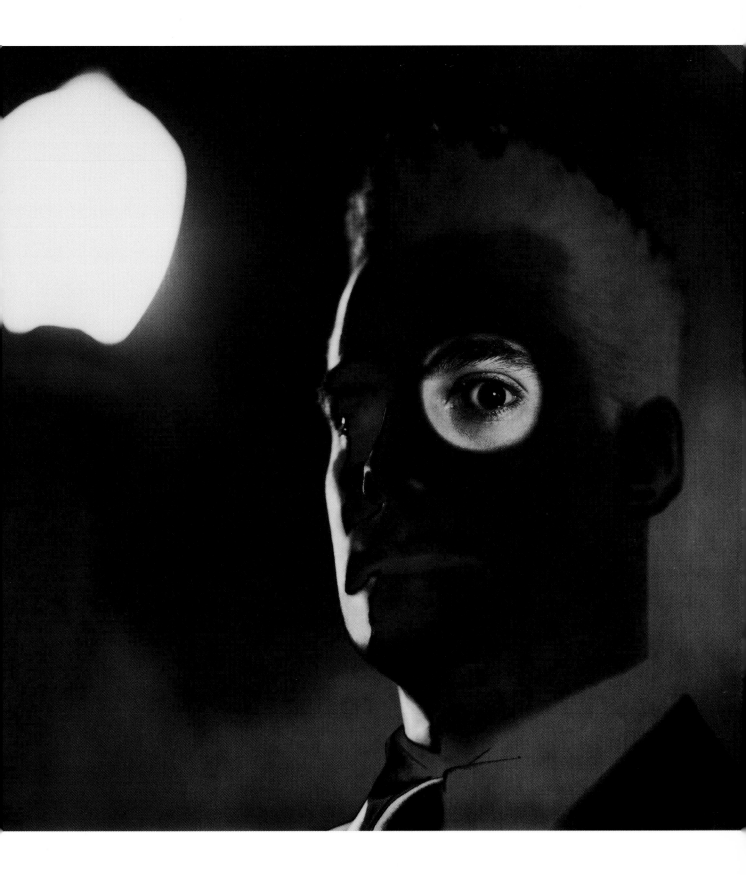

SUBJECT:	Michael Madsen
CLIENT:	Playboy
LOCATION:	Los Angeles, CA
NOTES:	60 Watt Bulb

I wanted to capture the look and feel of a garage. To do that, the main lightsource was a 60 watt light bulb with a "kiss" of fill light.

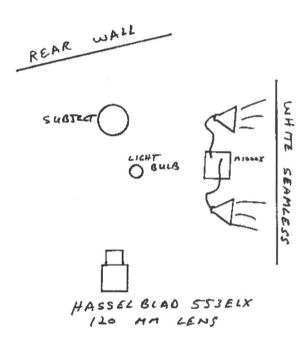

Rethinking Cliches

This photograph of Michael Madsen was shot for a "20 Questions" article in Playboy. The photo editor of the piece, Patty Beaudet Francés, mentioned to me that Michael Madsen had some "odd jobs" before he was a working actor. **One of the jobs was at a gas station. I immediately took a little artistic license with that and came up with this scenario.**

To get the look I wanted, I lit the shot primarily with the light bulb hanging down in the shot. I think what separates this shot from an available light photograph in the same situation is that there is shadow detail in this photograph. To get the detail I bounced two strobe heads off of a white piece of seamless paper from the same angle as the light, about 3/4 to the right, so the shadows would be the same. The seamless was about five or six feet from the subject. I used two heads so that the light would "wrap around" everything and fill in well.

Lastly I set the power of the two heads very, very low. They were at least 2.5 to 3 f/stops below the light bulb light that we metered on his face. To meter the light we would meter each part separately, turning off the light bulb to meter the strobe and unplugging the strobe to meter the light bulb. **This fill light is very subtle, but makes the difference in the shot.** The picture was exposed at and 1/8 of a second at about f/4.

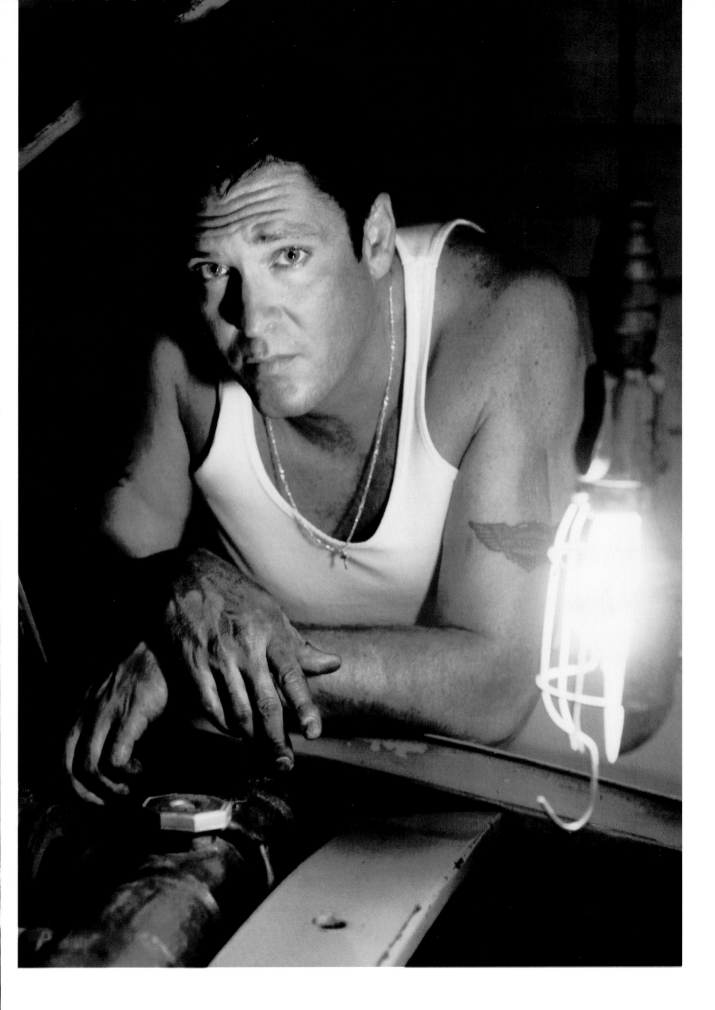

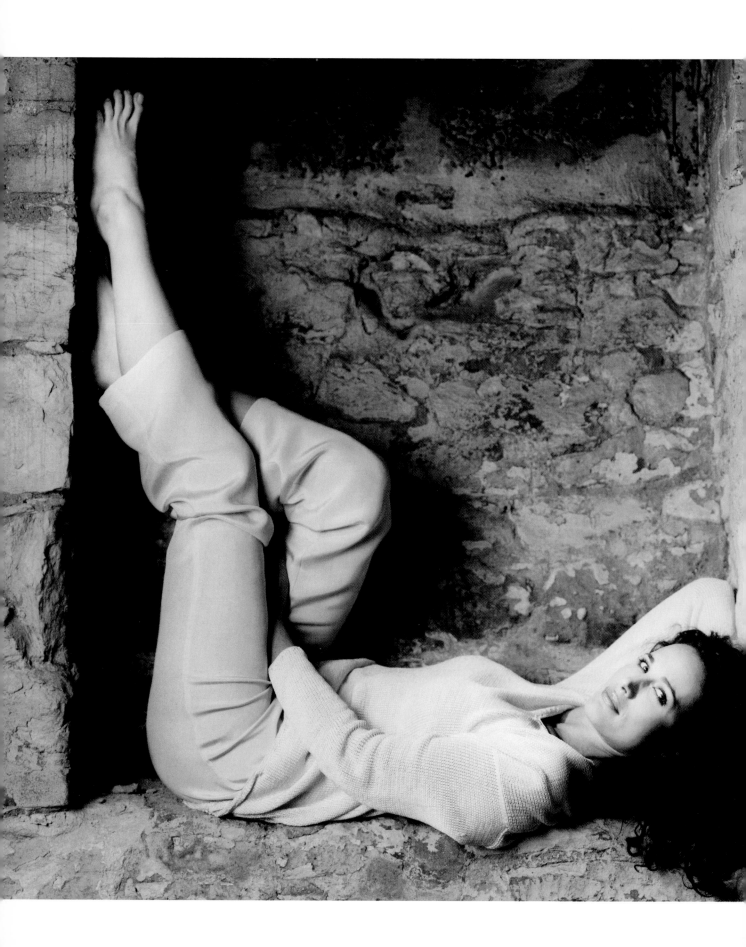

SUBJECT:	Andie MacDowell
CLIENT:	Movieline
LOCATION:	Austin, TX
NOTES:	Different Pose

Unusual Positions

Andie MacDowell was a cover assignment for Movieline Magazine. I had to fly down to Austin, Texas and shoot her on a day when she was not filming during the making of the movie "Michael." I have a photographer friend in Austin with a studio that I rented for the day, and he also aided me by finding a nearby location to do some additional shooting.

I spent the day before the session figuring out what I was going to shoot. I picked out yellow seamless paper for the cover, re-painted a studio wall white, picked up a chair, and scouted the restaurant next door to shoot in. **The first two situations would be for the cover. The clean walls and simple areas lend themselves to cover shots with type.** The couch would be for the inside, and the restaurant I would use to do what would be a more personal shot for me.

As you can already tell I like posing people in unusual positions, and this alcove was perfect for that. I loved the texture of the old stone and thought that it would work very well as the black and white situation for the piece.

The ceiling was very low, but I needed to get the light on her face high enough so that it would be going in a flattering direction. **Not only did the shot have to be interesting and personal, it was also a beauty shot of her.** I placed Dyna Lite head with a 10° grid spot on a c-stand just above the frame of the shot to the right. This allowed me to get the light in the right position. The only thing missing at this point was a fill-light to illuminate the rest of the scene. For the fill, I placed a softbox to the left of the camera, fairly straight on. She was wearing an off-white outfit so I Polaroided quickly until I got the right overall tone. You could still tell that clothes were white, yet the light on her face was dramatic. The nice thing about black and white Polaroid is that it only takes 30 to 40 seconds to develop so we sometimes use it if we cannot set up ahead of time and use the actors or real subjects while lighting.

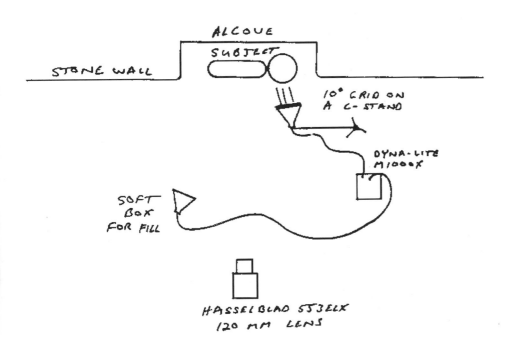

I shot this as an alternative to the more straight forward cover shots I was asked to do.

SUBJECT:	Johnny Depp
CLIENT:	Movieline
LOCATION:	Los Angeles, CA
NOTES:	Shot from the Ceiling

For this image I had to go up into the rafters at the Smashbox studios and shoot Johnny Depp from over the pool table.

This was a cover story for Movieline. I had to shoot several situations that were simple and clean to accommodate cover type. We shot two situations against a white, and another with a gray background. **At that point, I felt that the cover variations were well "covered," so to speak.**

For the inside spread I wanted to make an image that was something wholly different from the cover, and was also something that would be more to my own personal vision. **After all, that's why my clients hire me, for the way I see.**

The studio we were shooting in, Smashbox, has a pool table in the common area. Shots of people playing pool can be so overdone, so I needed to make even the pool table shot completely different from other shots done with a pool table. **I decided to shoot straight down on the table, and since Johnny Depp was not feeling well that day it became his favorite situation of the shoot.**

Dean Factor, one of the owners of the studio, allowed us to get a ladder and shoot from the rafters above the pool table. During the shoot we had a very perplexed studio assistant wondering what I was doing in the ceiling. **As always, we set everything up first with a stand-in, while Johnny relaxed. The complicated part of this setup was the logistics of securing the camera so that it would not fall on our subject.** I opted to hand hold the camera, but we affixed a safety line so it could not fall far. The other hazard was knocking dust down from the beam onto him and the table. This created a situation where I was balanced on a six-inch piece of wood and could not move for fear of falling or literally messing up the shot. As it was, my assistant, Jason, had to continually vacuum both the pool table and Johnny during the shoot. I did have to see my chiropractor the next day.

The image was lit with my Fresnel strobe from the upper right side of the frame, placed high and pointing across the table.

An Original Point-of-View

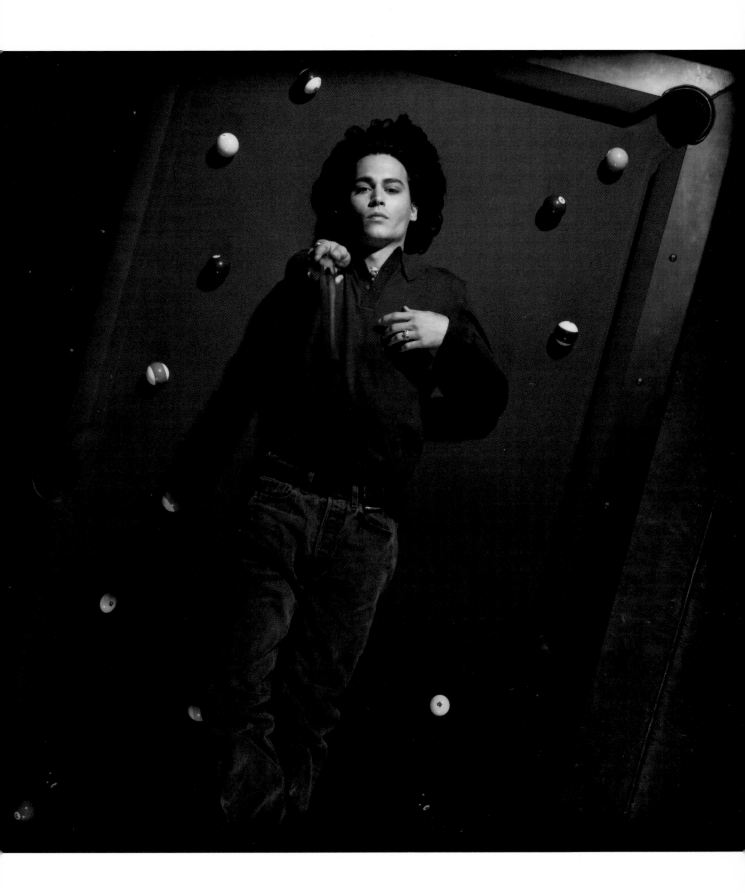

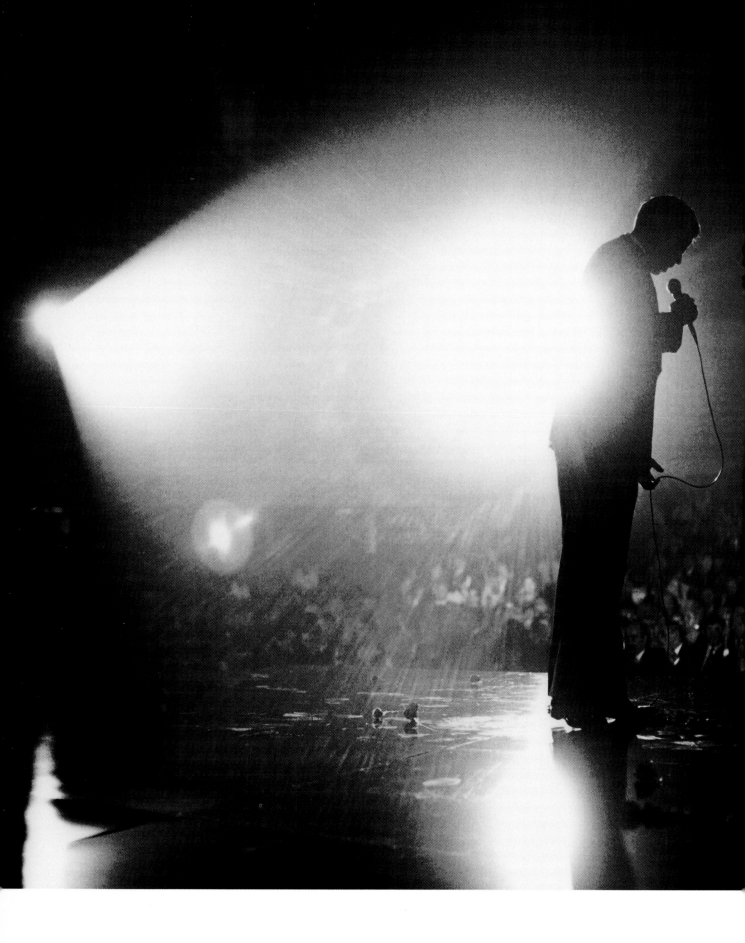

This image was from the set of the Sinatra mini-series. I liked this scene so much as I was watching the TV crew film it that **I asked the producer to hold the production for one twelve exposure roll of 120 film (about 2-3 minutes), while I got on stage with the actor.** The shot from the front would have been just a document of what they were doing, but when composed from behind, the shot was very dramatic and able to tell the whole story. Phillip Casnoff, the actor, was so good at playing Frank Sinatra that his entire body tells the story.

Most of the roll of film was shot as a straight silhouette but when the light moved at the right angle to cause a flare in the lens, that captured the feeling I wanted even more. I shot almost the whole roll and then had to leave the stage so the production could go on.

While I was on stage, I shot mostly without the flare, but then decided to try and use the flare to increase the atmosphere and mood.

On The Set

SUBJECT:	Sinatra Mini Series
CLIENT:	Entertainment Weekly
LOCATION:	Los Angeles, CA
NOTES:	Backlit by Stage Spot Light

THEATRICAL SPOTLIGHT

CROWD

STAGE

SUBJECT

CAMERA FLARE

HASSELBLAD 80 MM LENS

SUBJECT:	Sinatra Mini Series
CLIENT:	Entertainment Weekly
LOCATION:	New York, NY
NOTES:	Fresnel Strobe, Fuji Panoramic

MANHATTAN

HUDSON RIVER

PIER

PIER

SUBJECT

FUJI PANORAMIC CAMERA

SPOTTED FRESNEL HEAD

DYNA-LITE M 1000X

I used a panoramic camera to capture the environment and feel of being on location in Hoboken, NJ, overlooking New York City.

This was shot on a day in New York when actor Phillip Casnoff had some time off from shooting. **You always try to go on a set when the talent has the most time available in the schedule. Sometimes that's very hard because production schedules on movies and TV movies change so much.** This day we were lucky. I took Mr. Casnoff to the piers in Hoboken, New Jersey were you could see Manhattan in the background.

All during the production I was responsible for coverage of the movie (I shot 35mm stills while they were filming and behind the scenes), as well as portraits of those involved. To make the coverage different I was doing some of the overviews of the production with a 2-1/4" panoramic camera. In this case I though it would be interesting to shoot an action portrait with the panoramic camera. To keep the drama I used the Fresnel light so that I could back way up and still get a concentrated spot of light on the subject's face. To focus and precisely frame the camera I had to open it up and place a piece of frosted Mylar on the focal plane as a makeshift ground glass. This allowed me to see what I was getting, while I had a piece of black cloth over my head to keep it dark.

SUBJECT:	Marcia Gay Harden
CLIENT:	Entertainment Weekly
LOCATION:	Los Angeles, CA
NOTES:	Available Light

As I was setting up another shot I was told Marcia was ready to shoot. I quickly grabbed a Hasselblad and shot her in the alley with the available light.

Sometime there is just no time to set up any lights. While working on this series of pictures on the Sinatra mini-series I had to shoot all the major actors involved. As we were setting up to shoot another portrait which required a lot of lighting, I was told that Marcia Gay Harden, who played Ava Gardner, was available to shoot.

I grabbed my Hasselblad with a few film backs, a meter and an extra lens and ran outside to her. The light was soft enough that I could shoot down the narrow alleyway outside her trailer in either direction. So I picked the best view for the background and had the sun light softly coming in from behind her. Again, it was soft enough to work without a silk in the sky to soften it, so I could work fast and with no additional equipment.

What makes the shot work well is Ms. Harden's skill as an actress and her comfort and ease in front of a still camera. **She just "lit up" for me and also fell right into her Ava Gardner character. The synergy that I talk about in this book comes from me watching the light fall on her face, watching the background and composition and giving her little bits of direction and new ideas so that the two of us are working together – guiding her through a great shoot.** As such, I added a newspaper to the shot just to give her something to do with her hands. In the end, it was hard to choose the best frame from all of the expressive moments we had.

WHITE SEAMLESS

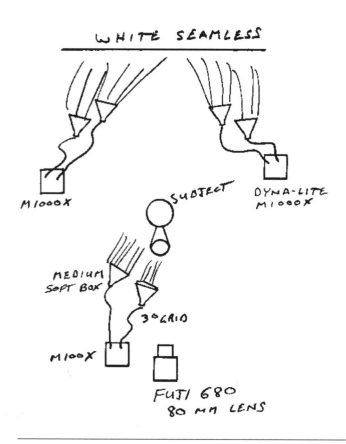

M1000X
SUBJECT
DYNA-LITE
M1000X
MEDIUM
SOFT BOX
3° GRID
M100X
FUJI 680
80 MM LENS

Happy Accidents

This image was created for Yahoo! as part of a marketing piece for the company. I had seen some very bold and engaging advertising that Yahoo! did for their search engine, so when I got the assignment to shoot a series of people for a direct mail piece, I wanted to make them just as interesting.

Accomplishing this was a somewhat tricky feat because it was also **important for the piece that the subjects still looked like everyday, ordinary people.** The model for this image was used as the "sports fan" for the brochure, so I really wanted him to be "in your face." I had Xavier, our incredible wardrobe and prop stylist, bring in several old-fashioned megaphones. Then I shot the subject and megaphone with a wide angle lens to maximize the appearance of the megaphone by creating a bit of distortion.

A soft box was used to light the subject, who was posed in front of white seamless paper. Four heads were used to light the white seamless so that it was one stop brighter than the subject and went completely white. A 3° grid in the megaphone threw light into the megaphone so you can see his mouth. The grid was placed low to skim off the inside surface of the megaphone and catch the texture and detail on the seam.

I was shooting it pretty much straight on when my assistant, Jason, and I noticed the camera had moved and the framing was even cooler this way. **Happy accidents are the best.**

This is a standard white where the background is lit one stop brighter than the foreground. In addition to the soft box (camera left) I lit the subject's face with a 3° grid spot aimed into the megaphone to light its inside seam.

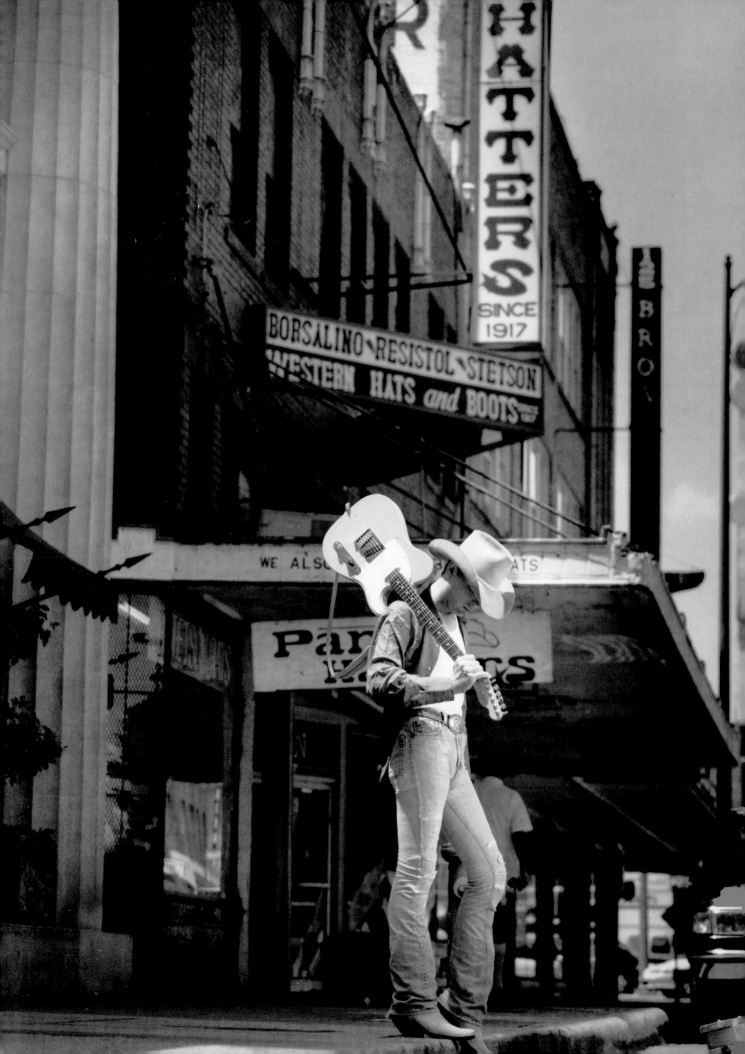

Accidental Locations

SUBJECT:	Dwight Yoakam
CLIENT:	American Way
LOCATION:	San Antoinio
NOTES:	Polaroid 665

A soft box on a portable strobe was used from the side to add a "kiss" of light to his face.

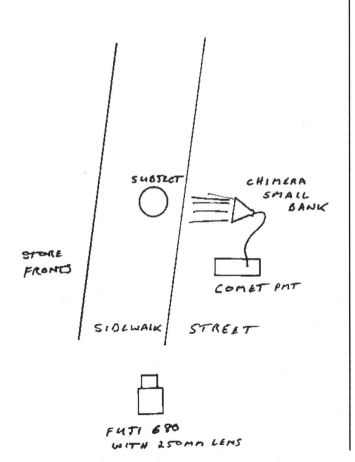

STORE FRONTS

SUBJECT

CHIMERA SMALL BANK

COMET PMT

SIDEWALK STREET

FUJI 680
WITH 250MM LENS

American Way Magazine assigned me to go to San Antonio, Texas, to shoot a cover story on Dwight Yoakam while he was filming the movie "The Newton Boys." On my shoot day, he had a break from the movie in the middle of the day, but he needed to have some hats blocked (adjusted) at a local Western store. So he invited us to do the shoot there. We gladly accepted thinking the situation might offer some possibilities. After Dwight took care of his business we started shooting him around the store with all the hats. **Then I decided to move on to another situation, so I grabbed the Fuji GX 680 camera and laid on the ground almost in the street to get this shot.** My assistant set up one Comet head flash with a small soft box in the street to punch a little light on the subject. I shot this hand held at 1/400 second. I backed up from the subject and used a long lens to pull in all the atmosphere of the location.

This image was part of an album cover and packaging for a Brazilian metal band called Sepultura. They went to the middle of Brazil to record an acoustic song with the Xavantes Indians. It was an amazingly long trip to an extremely isolated village. To this day I don't exactly know where I was. All I know is that I flew to Sao Paulo, Brazil, took another airliner to Goiania, Brazil, and then took an almost two hour turbo prop plane during which I did not see any signs of civilization until we touched down at the village air strip. The band rented two planes but, even so, water was not brought in until the second day. Neither I nor the videographer could bring assistants. **Until the planes came back the second day I had no lights, and was making images at night by flashlight.**

The next day, as the band played under a mango tree, the Indians did a meditative chant and danced. **The singing and dancing were incredibly moving and I wanted to capture the movement of the silhouetted Indians.**

If the light had been very low I could have used a long exposure, maybe a few seconds and have gotten some great blurring. Since this was the middle of the day, however, I had to come up with another solution. I tried using neutral density gels, but at the smallest f/stop, even with gels over the lens, I was only down to about 1/8 of second, and that did not look like much on the Polaroid. Then It came to me – **a blur is like lots of little exposures** all added up, so I could make six or eight multiple exposures on the same piece of film and get the same effect. I Polaroided it and it worked! I set up the camera on a little table-top tripod, calculated the f/stop for six exposures on one piece of film and started shooting. I meditate, so I used that experience **to slow my self down enough to very, very carefully remove the camera back after each frame, let the camera wind, the replace the film-back.** I also changed the number of multiple exposures as I was shooting so that it would naturally bracket the film exposure. The process was very slow, but it worked.

The shot was later was used on t-shirts for the band, and was featured in their packaging.

To try and get the look of a long time exposure I shot six to eight multiple exposures on one frame.

SUBJECT:	Brazilian Indians
CLIENT:	Road Runner Records
LOCATION:	Brazil
NOTES:	Multiple Exposures

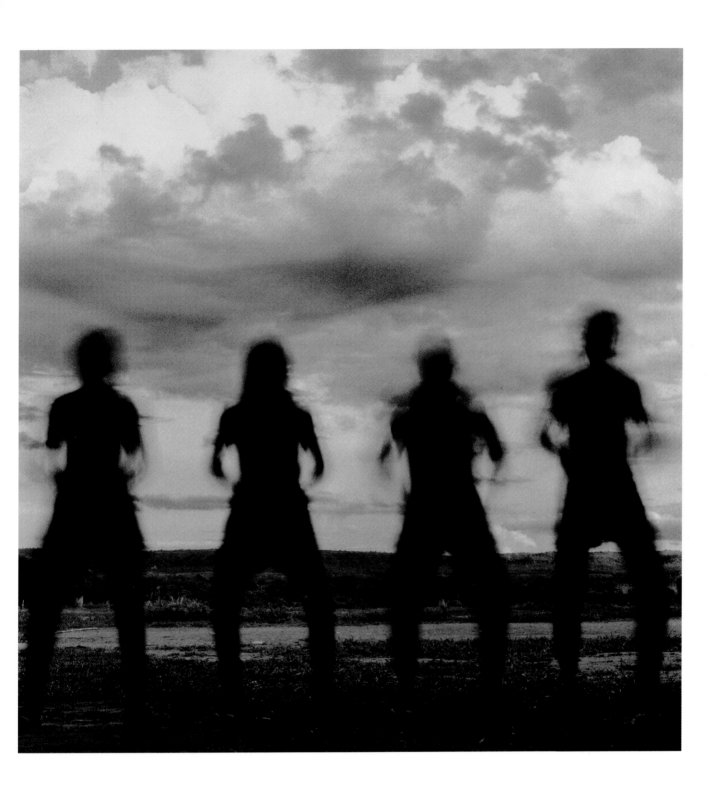

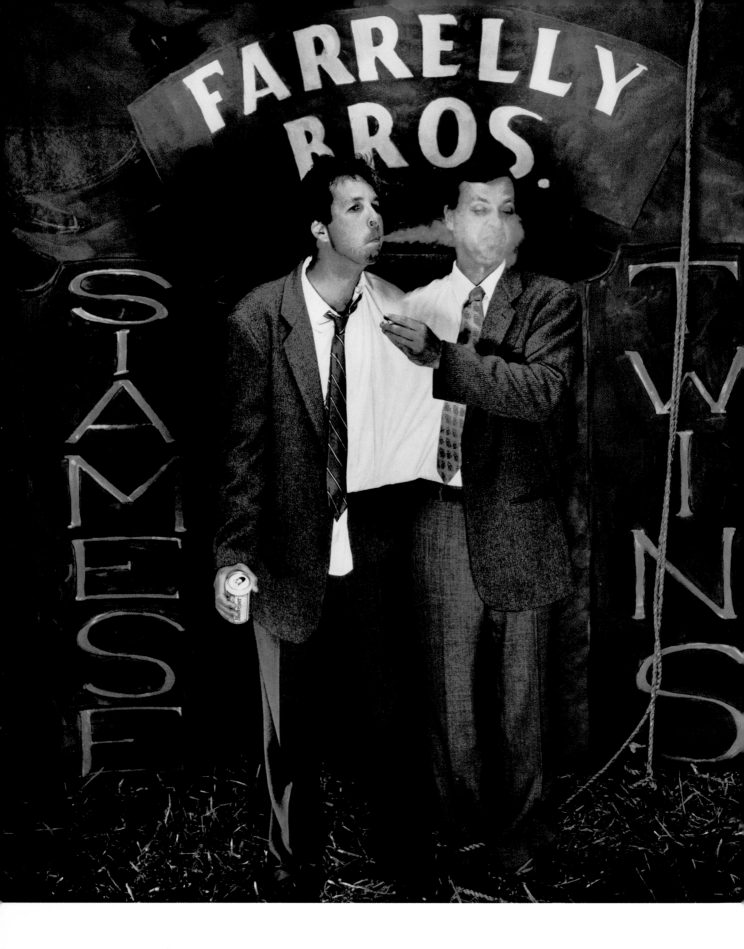

Building Sets

Entertainment Weekly asked if I would fly to Washington D. C. to do a feature on the Farrelly Brothers, the directors of "Dumb and Dumber" and "There's Something About Mary."

After going to a press screening of the movie they were doing at the time, "King Pin," I got on the phone to the L.A. photo editor, Michael Kochman. **It's great when you can collaborate well with an art director or photo editor – Michael and I always come up with some great ideas.** After our brainstorming session we had two concepts, one of which was the brothers as Siamese twins.

A few weeks before, I met a set builder in New York who had just moved to Washington D.C., so I explained to him **our concept of the sort of "retro circus" background, and making the brothers Siamese twins.** To make the set, the set builder researched historical circus photographs and drew elements from several to achieve the custom backdrop which is the central part of the set. The rest of the set was essentially hay and a rope.

To put an edge on the shot I wanted to light it subtly, but differently. I wanted it to look like they were plastered against this wall. If ring light was not so overused I would have lit it with one, but instead the main light for the shot was a very small softbox directly under the lens. To give a little detail to the shot I used a backlight on their feet, which shows the hay and the ground. Lastly, to fill the shot, I opened the garage door of the studio I was using and slowed my shutter speed to add a little fill light.

Once the subjects got into costume, they helped create the magic of the shot. One got to play the good brother, the other was the cigarette smoking, beer drinking rude brother. They almost did not want to do this shot because the concept was so right on the nose – they are working on an upcoming comedy about Siamese twins! I love that.

The concept of this shot was so right on the nose that they hesitated to do it for fear that it would give away their next movie idea.

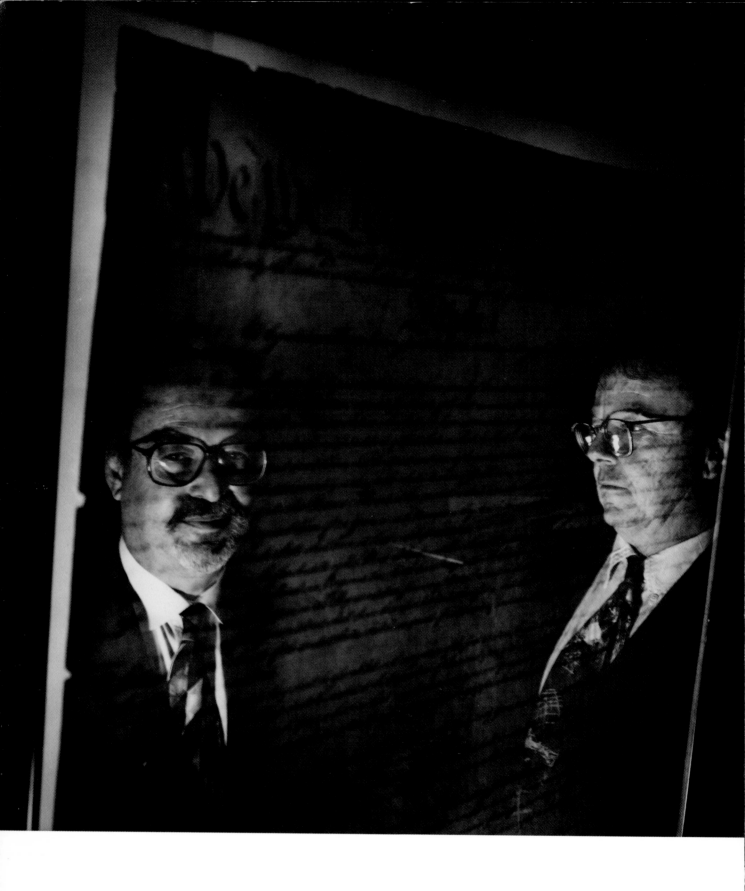

WALL BILL of RIGHTS

OPEN HEADS

DYNALITE M1000X

HASSELBLAD 553 ELX 80MM LENS

SUBJECTS

GQ's Tyler Pappas assigned me to photograph two right-wing radicals who were the subjects of a not-so-favorable story. When I walked into their office, the space was very boring and cluttered. **The only thing in the office I found interesting was the United States Bill of Rights framed on the wall.**

I first photographed the subjects as my interpretation of a Diane Arbus portrait. I was in their faces very flat on and had them stand side by side. Next I wanted to try shooting the Bill of Rights with their reflection in it. To add an edge to it I would also under light them, given the editorial content, in a scary way. I set up the camera looking at the picture frame from an angle (if I had shot straight on I would have been photographing myself). I then figured out the exposure for the Bill of

Rights with Polaroid using the room light to illuminate the picture frame.

I placed the subjects so I could see them as reflections in the glass. Now, here is the trick: if I was getting an f/8 for the overall picture, I would need to have the flash on them at about 2 to 3 stops brighter than that to see them well in the glass. Glass is an inefficient mirror, and hence only reflects a certain percentage of the light, allowing the rest of the light to go through it. **By putting that much light on the subjects you increase the amount of light reflected back in the glass.** Anyway it worked, and of course I did put the light nice and low.

SUBJECT:	Political Advocates
CLIENT:	GQ
LOCATION:	Los Angeles, CA
NOTES:	"Forced" Reflection

This image was an interesting self-assignment for me. Every year for the past few years, I've taught at the Santa Fe Photographic Workshops. One year I got back to the director too late with my schedule and he booked Albert Watson for my portrait slot. At first I was disappointed, but instead of walking away I decided to enroll in his class. This photo was taken for Albert's only assignment during the week, which was to conceive and execute a high quality, creative portrait.

Since I tend to shoot so many people who would rather not take off their clothes, I thought I would do a nude. I had not done one as a serious study in many years. In addition, someone suggested that an interesting location might be the Los Alamos Nuclear Labs junk yard. I did not know what I was going to do, but set out with an open mind to see what I would come up with. After shooting for a while I found a metal box that was once used as a containment unit, the type you slip your hands in through gloves mounted on the outside. The side of

the box was open, so I had the model get in from the side and I shot her through the glass front (the two round holes are where the gloves used to be).

As we were shooting, the sky turned to gray and it started to rain, which meant that the light became blue in tone. **Instead of fighting the color change in the sky, I went with it and enhanced it by using tungsten balanced film to make it bluer.** I then added a CTB filter (or ½ Booster Blue) to make her skin tone go blue. CTB filters are blue filters which are used to convert tungsten light (which has an orange tone) to daylight (with a more neutral tone). They come in varying strengths, a full being a complete conversion to daylight. Even with tungsten film and filter, most skin tone still won't go blue without blue on the lights, so a blue gel was added to the strobe head (one Comet PMT 1200).

The rain and the sky color add mood to what my assistant has titled "Jill in the Box."

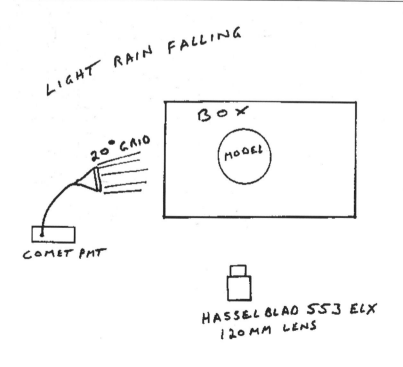

LIGHT RAIN FALLING

BOX

MODEL

20° GRID

COMET PMT

HASSELBLAD 553 ELX
120MM LENS

The model was inside this metal box at the junk yard for the Los Alamos, NM nuclear research labs. I shot through the glass in the front of the box with the model lit from the opening on the side.

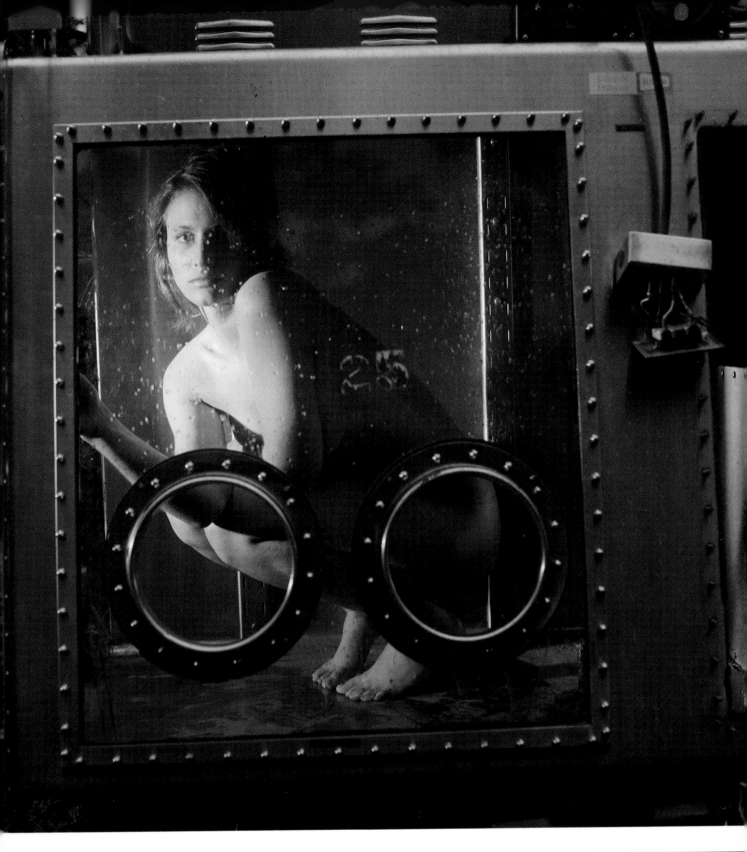

SUBJECT:	Jill in the Box
CLIENT:	Self Assignment
LOCATION:	Los Alamos, NM
NOTES:	Film: Kodak EPY

Other Books from
Amherst Media, Inc.

Infrared Photography Handbook

Laurie White

Covers b&w infrared photography: focus, lenses, film loading, film speed rating, heat sensitivity, batch testing, paper stocks, and filters. Photos illustrate IR film in portrait, landscape, and architectural photography. $29.95 list, 8½x11, 104p, 50 b&w photos, charts & diagrams, order no. 1419.

Into Your Darkroom Step-by-Step

Dennis P. Curtin

This is the ideal beginning darkroom guide. Easy to follow and fully illustrated each step of the way. Includes information on: the equipment you'll need, set-up, making proof sheets and much more! $17.95 list, 8½x11, 90p, hundreds of photos, order no. 1093.

Outdoor and Location Portrait Photography

Jeff Smith

Learn how to work with natural light, select locations, and make clients look their best. Step-by-step discussions and helpful illustrations teach you the techniques you need to shoot outdoor portraits like a pro! $29.95 list, 8½x11, 128p, b&w and color photos, index, order no. 1632.

Freelance Photographer's Handbook

Cliff & Nancy Hollenbeck

Whether you want to be a freelance photographer or are looking for tips to improve your current freelance business, this volume is packed with ideas for creating and maintaining a successful freelance business. $29.95 list, 8½x11, 107p, 100 b&w and color photos, index, glossary, order no. 1633.

Wedding Photography:
Creative Techniques for Lighting and Posing

Rick Ferro

Creative techniques for lighting and posing wedding portraits that will set your work apart from the competition. Covers every phase of wedding photography. $29.95 list, 8½x11, 128p, b&w and color photos, index, order no. 1649.

Professional Secrets of Advertising Photography

Paul Markow

No-nonsense information for those interested in the business of advertising photography. Includes: how to catch the attention of art directors, make the best bid, and produce the high-quality images your clients demand. $29.95 list, 8½x11, 128p, 80 photos, index, order no. 1638.

Achieving the Ultimate Image

Ernst Wildi

Ernst Wildi teaches the techniques required to take world class, technically flawless photos. Features: exposure, metering, the Zone System, composition, evaluating an image, and more! $29.95 list, 8½x11, 128p, 120 b&w and color photos, index, order no. 1628.

Black & White Portrait Photography

Helen Boursier

Make money with b&w portrait photography. Learn from top b&w shooters! Studio and location techniques, with tips on preparing your subjects, selecting settings and wardrobe, lab techniques, and more! $29.95 list, 8½x11, 128p, 130+ photos, index, order no. 1626

Handcoloring Photographs Step-by-Step

Sandra Laird & Carey Chambers

Learn to handcolor photographs step-by-step with the new standard in handcoloring reference books. Covers a variety of coloring media and techniques with plenty of colorful photographic examples. $29.95 list, 8½x11, 112p, 100+ color and b&w photos, order no. 1543.

Fine Art Portrait Photography

Oscar Lozoya

The author examines a selection of his best photographs, and provides detailed technical information about how he created each. Lighting diagrams accompany each photograph. $29.95 list, 8½x11, 128p, 58 photos, index, order no. 1630.

Family Portrait Photography

Helen Boursier

Learn from professionals how to operate a successful portrait studio. Includes: marketing family portraits, advertising, working with clients, posing, lighting. Includes images from a variety of top portrait shooters. $29.95 list, 8½x11, 120p, 123 photos, index, order no. 1629.

Photographer's Guide to Polaroid Transfer

Christopher Grey

Step-by-step instructions make it easy to master Polaroid transfer and emulsion lift-off techniques and add new dimensions to your photographic imaging. Fully illustrated every step of the way to ensure good results the very first time! $29.95 list, 8½x11, 128p, order no. 1653.

Creative Techniques for Nude Photography

Christopher Grey

Create dramatic fine art portraits of the human figure in black & white. Features studio techniques for posing, lighting, working with models, creative props and backdrops. Also includes ideas for shooting outdoors. $29.95 list, 8½x11, 128p, order no. 1655.

Wedding Photojournalism

Andy Marcus

Learn the art of creating dramatic unposed wedding portraits. Working through the wedding from start to finish you'll learn where to be, what to look for and how to capture it on film. A hot technique for contemporary wedding albums! $29.95 list, 8½x11, 128p, order no. 1656.

Professional Secrets of Wedding Photography

Douglas Allen Box

Over fifty top-quality portraits are individually analyzed to teach you the art of professional wedding portraiture. Lighting diagrams, posing information and technical specs are included for every image. $29.95 list, 8½x11, 128p, order no. 1658.

Photo Retouching with Adobe Photoshop

Gwen Lute

Designed for photographers, this manual teaches every phase of the process, from scanning to final output. Learn to restore damaged photos, correct imperfections, create realistic composite images and correct for dazzling color. $29.95 list, 8½x11, 128p, order no. 1660.

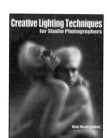

Creative Lighting Techniques for Studio Photographers

Dave Montizambert

Master studio lighting and gain complete creative control over your images. Whether you are shooting portraits, cars, table-top or any other subject, Dave Montizambert teaches you the skills you need to confidently create with light. $29.95 list, 8½x11, 128p, order no. 1666.

Storybook Wedding Photography

Barbara Box

Barbara and her husband shoot as a team at weddings. Here, she shows you how to create outstanding candids (which are her specialty), and combine them with formal portraits (her husband's specialty) to create a unique wedding album. $29.95 list, 8½x11, 128p, order no. 1667.

Fine Art Children's Photography

Doris Carol Doyle

Learn to create fine art portraits of children in black & white. Included is information on: posing, lighting for studio portraits, shooting on location, clothing selection, working with kids and parents, and much more! $29.95 list, 8½x11, 128p, order no. 1668.